HIDDEN
HISTORY
of
MAINE

HIDDEN
HISTORY
of
MAINE

HARRY GRATWICK

Charleston London

THE
History
PRESS

Published by The History Press
Charleston, SC 29403
www.historypress.net

Copyright © 2010 by Harry Gratwick

First published 2010

Manufactured in the United States

ISBN 978.1.59629.815.6

Library of Congress Cataloging-in-Publication Data

Gratwick, Harry.
Hidden history of Maine / Harry Gratwick.
p. cm.
Includes bibliographical references.
ISBN 978-1-59629-815-6
1. Maine--History. 2. Maine--Biography. I. Title.
F19.G73 2010
974.1--dc22
2010003085

Notice: The information in this book is true and complete to the best of our knowledge. It is offered without guarantee on the part of the author or The History Press. The author and The History Press disclaim all liability in connection with the use of this book.

This book is dedicated to the memory of Walter Schneller, distinguished history teacher at the Hackley School in Tarrytown, New York; mentor, colleague and friend. Walter referred to his place on Peaks Island in Casco Bay as his "sacred space."

Contents

CONTENTS

FOREWORD

I n the town of Warren there is a playground next to the St. Georges River. Cross a footbridge and you're on a hiking trail. To your right is a wide, straight depression in the ground, flanked by low berms on either side. As you walk down the trail, the berms become about eight feet high. The berms are straight and, at the end, enclosed in a stone wall. It's man-made, but it is impossible to tell what this structure used to be. In fact, it was a lock in the Georges River Canal, which you'll learn about in part three of *Hidden History of Maine*.

This is truly hidden history. You won't find accounts of this canal in traditional history books or even modern guidebooks, which is why this new book by Harry Gratwick is so much fun. He unearths captivating stories about Mainers you probably haven't heard about before.

Harry was a history teacher and administrator at Germantown Friends School in Philadelphia for forty years, and one gets a sense of an excellent teacher's enthusiasm for his subject in Harry's writing. I've been fortunate to work with Harry, who writes for the *Working Waterfront* newspaper and *Island Journal* magazine, both of which I edit. I am always impressed with Harry's infectious curiosity. You can hear the excitement in his voice when he tells you about the latest story he's working on.

Harry has a knack for finding unusual characters. One of the stories he wrote for me was about a math professor, with no boatbuilding experience, who embarked on a thirteen-year mission to build a Friendship sloop. He's also written about four men on Vinalhaven, called the Four Fossils, who built

a retaining wall for a town sidewalk using granite from an island quarry that had been dormant for over forty years.

In his first book, *Penobscot Bay: People, Ports and Pastimes*, Harry explored this region's rich history. Harry has been coming to Vinalhaven, the most populated island in the bay, since the 1940s, and this book resonates with the personal connection he feels to the region's history.

In his new book, Harry has expanded his range to the entire state. He writes about missionaries, soldiers, politicians, explorers, inventors and ballplayers. With his training as a history teacher, we can be assured that the history is solid. But by focusing on the stories of people, he adds a new dimension to the telling of Maine history. In our small state, individuals often have a greater impact on the state than impersonal historical forces.

You will learn that the most influential figure in Maine's early history was not a famous explorer but a little-known royalist, Sir Ferdinando Gorges. You'll read about the African American shipyard worker Robert Benjamin Lewis, who invented a machine that prepared hemp for caulking ships. And you'll also read about one of the greatest opera divas of the nineteenth century, Lillian Nordica, who was born in a Farmington cabin.

Harry has the unusual gift of being an enjoyable storyteller who also gets his facts right. So pull up a chair, immerse yourself in *Hidden History of Maine* and enjoy these tales of fascinating Mainers from the past four hundred years.

David Tyler
Editor of the *Working Waterfront* and *Island Journal*
Publications of the Island Institute, Rockland, Maine

Acknowledgements

I am very grateful to Valerie Morton and Linda Whittington, librarians at the Vinalhaven library who provided me with invaluable assistance by cheerfully responding to my frequent requests for books through interlibrary loan. I am also greatly indebted to Susan Hutchens at the Arnold Expedition Historical Society in Pittston, Maine, who went out of her way to accommodate my requests, including providing pictures of the Arnold Expedition painted by S.W. Hilton.

In addition I would like to thank the following persons for their help and advice on specific topics included in this book: Sue Radley; Bill Chillis; Loretta Chillis and Roy Heisler at the Vinalhaven Historical Society; Dana Lippitt at the Bangor Museum and Center for History; Bill Cook and Elizabeth Stevens at the Bangor Library; Barbara Larson and Dick Ferren at the Warren Historical Society; Charlotte Singleton at the Mount Desert Island Historical Society; Dan O'Connor at the Rockland Library; Ben Fuller at the Penobscot Marine Museum; Bill Barry; Dani Fazio; Bob Greene at the Maine Historical Society; Richard Lindemann at the Bowdoin College Special Collections; Nathan Lipfert at the Maine Maritime Museum; Peter Harrington and Tad Baker at the Portsmouth Athenaeum; and Bonnie Lander at the Nordica Homestead Museum in Farmington.

Finally, I am very appreciative of the help I received from Steve Webb, my Williams College classmate, and David Tyler, publications director at the Island Institute in Rockland. And a special thanks to my wife, Tita, for her careful proofreading and editing suggestions, as well as her ongoing love and support.

ACKNOWLEDGEMENTS

Images credited to the Maine Historical Society are courtesy of the Maine Memory Network. Visit www.MaineMemory.net to browse thousands of images spanning Maine history, and purchase reproductions at www. VintageMaineImages.com.

Introduction

M any men explored the coast of Maine in the sixteenth and seventeenth centuries. Some sailed for personal glory; others voyaged to serve king (or queen) and country. The bountiful fishing grounds attracted hundreds more, and a few were looking for the elusive Northwest Passage. Their names constitute a veritable who's who of North American explorers. Giovanni da Verrazzano, John and Sebastian Cabot, Humphrey Gilbert, Samuel de Champlain, Henry Hudson and Captain John Smith are just some of the better-known names of those who sailed the Maine coast.

This brings us to Ferdinando Gorges. In his book *Islands of Maine*, Bill Caldwell describes Gorges as "the Father of Maine." "Gorges deserves better," Caldwell tells us. For example, neglected Fort Gorges in the middle of Portland Harbor is the only place in the entire state that bears his name. In 1910, when voters in York, Maine, were asked if they wanted to ratify an act by the Maine legislature to "divide the Town of York and Establish the Town of Gorges," the legislation was soundly defeated.

The persistent Gorges pursued his dream of colonizing Maine for forty years, in the process spending over £20,000 of his own money. Since the title of my book is *Hidden History of Maine*, I feel it is appropriate to use this little-remembered man as the introductory figure in the examination of historic Maine figures that follows.

Sir Ferdinando Gorges was an Englishman with a Latin-sounding name. Gorges was a descendant of Ralph de Gorges, who came from

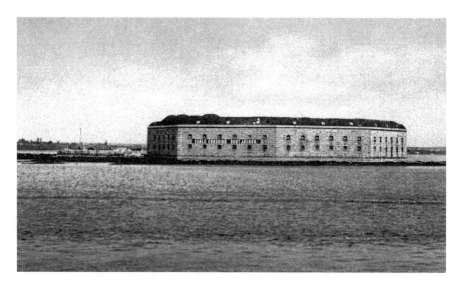

Fort Gorges was built during the Civil War and sits at the entrance to Portland Harbor in Casco Bay. It is named after Sir Ferdinando Gorges and is the only place in the state that bears his name. *Courtesy of Maine Memory Network.*

Normandy in the eleventh century with William the Conqueror. Gorges's life is interesting for several reasons. Unlike the men listed earlier, Gorges never crossed the Atlantic Ocean. He was born in 1565 or 1566 into a prosperous English family.

Gorges was an energetic fellow. He fought against the Spanish Armada, he commanded a regiment in Flanders, Queen Elizabeth knighted him and he was a close friend of Sir Walter Raleigh. Then, in 1605, while Sir Ferdinando was governor of the coastal town of Plymouth, an event occurred that would change his life.

That year, Captain George Weymouth returned to England with five Abenakis he had kidnapped from Penobscot Bay. He landed at Plymouth and presented three of the Native Americans to Gorges as a gift. Gorges took them into his household, and as he taught them the rudiments of English, he learned much about the lands that would come to be known as the province of Maine. University of New Hampshire professor Charles Clark writes, "From that moment, until he died forty two years later, Gorges's life was dominated by a single passion: to sponsor colonies described in broken English by his homesick captives."

In spite of his swashbuckling past, Gorges was a practical businessman. He immediately saw an opportunity to build a successful fishing enterprise

in North America. Gorges helped to organize the Plymouth branch of the Virginia Company, and in 1607, he sponsored the ill-fated Popham colony, which will be discussed in the first chapter.

The Popham failure was a setback; Gorges termed it "a wonderful discouragement." In 1616, however, he financed a more modest trip under the leadership of Richard Vines. Vines landed at the mouth of the Saco River and made his way upstream to what is now Biddeford. The party built cabins and spent a reasonably comfortable winter. To quote Louise Dickinson Rich, "This little expedition settled forever the question of whether white men could endure the Maine climate and marked the beginning of the colonization of Maine."

In 1622, Sir Ferdinando and Captain John Mason were given a grant of land by the Plymouth Council that included portions of Maine and New Hampshire. They divided the lands, with Gorges ultimately receiving the portion known as the province of Maine. The 1630s saw rapid growth, as Gorges concentrated on developing the Kittery and York areas. As settlements in Maine grew, however, bickering among them increased. Gorges was hauled before Parliament more than once to answer charges that he and the Plymouth Company were running the colony for "their own private gain."

One must remember that in the 1630s England was in the midst of a fierce struggle between the monarchy and Parliament that would culminate in civil war in the 1640s. As a staunch royalist, Gorges was naturally the target of frequent parliamentary investigations. The result was that in 1635, over Gorges's desperate protests, the Plymouth Company was disbanded. "I have spent the flower of my life in promoting new settlements on a remote continent," Gorges lamented.

Ten years later, an elderly Gorges was making plans to sail to his beloved New World province. As his ship was being launched, it rolled over on its side and "broke" apart. Ferdinando Gorges, who had devoted forty years of his life to colonizing Maine, was never to set foot on its shores. With the coming of the civil wars and the fall of Charles I, Sir Ferdinando's world fell apart. He died in 1647 a broken old man of almost eighty. The next year, the king was executed.

For the remainder of the seventeenth century, Maine was a pawn between Massachusetts, New York and the English monarchy. Massachusetts had watched Maine grow with both apprehension and greed. In 1652, with Gorges no longer around, the colony's leaders in Boston decided to seize the moment. Massachusetts Bay revised its charter and extended its boundary

eastward to Casco Bay. Shortly after this, the boundary was extended to Penobscot Bay. Maine had been absorbed by the Massachusetts Bay Colony.

When the monarchy was restored in England in 1660, the new king, Charles II, had different plans. In 1664, royal commissioners informed settlers living in coastal Maine that their lands had been added to Cornwall County and they were now part of the province of New York. Royal authorities did not follow up on the king's directives, however, and in the 1670s Massachusetts resumed de facto control of the western part of Maine.

The last step in Maine's evolution as a province occurred in 1691–92, following the Glorious Revolution in England. The new English sovereigns, William and Mary, proclaimed that Massachusetts, including the province of Maine, was henceforth a royal colony. Although the Puritan Cotton Mather denounced Maine as nothing more than "a desert" (it had no churches), others would say that Massachusetts's imperialism had finally triumphed. Maine remained under Massachusetts's control until it became a state in 1820. Throughout the eighteenth and early nineteenth centuries, Maine, as a frontier territory, continued to be a battleground between the English, French, Americans and Native Americans.

This book will examine the lives of some of the people—the sung and the unsung—who have contributed to Maine's development over the last four centuries. It is not intended to be an inclusive or comprehensive history. Rather, the emphasis is on the variety of men, and a few of the women, who have influenced the history of Maine, the United States and, in some cases, the wider world.

Part I

Colonial Maine

The Popham Colony: An Unfortunate Beginning

Early in the seventeenth century, England, France and Spain waged a bitter contest for lands in North America. The Spanish had begun to settle in Florida as early as 1513 and were in the process of laying claim to lands as far north as South Carolina.

The French were led by legendary voyageur Samuel de Champlain, who was the first man to thoroughly chart the coast of present-day Maine. From 1604 to 1606, Champlain led three expeditions from his base on the Saint Croix River, which is on the border of Maine and New Brunswick. David Hackett Fisher, in *Champlain's Dream*, tells us that his boat was called a patache and that it was about forty feet long. Fisher adds, "He quickly discovered that the coast of Maine could be a hard school for a new commander." Champlain would chart the coast as far south as Cape Cod.

The new king of England, James I, was very much aware of the French and Spanish advances in North America and was determined to establish a permanent English presence. Indeed, James is considered by historians to be the founder of the British Empire. James's first action was to issue a royal charter establishing the Virginia Company. In reality, this was actually two companies that were formed to execute the royal will. The London Company was directed to colonize lands south of the Hudson River as far as Spanish Florida. The Plymouth Company was granted lands to the north of the Hudson as far as New France in Maine.

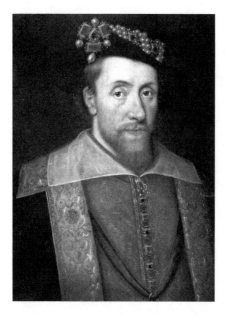

James I was king of England from 1603 to 1625. James was determined to establish a permanent English presence in North America and is considered by many historians to be the founder of the British Empire. *Author's collection.*

Hearing of Champlain's voyages, James, prodded by Ferdinando Gorges, moved rapidly. In 1607, two expeditions left England for North America. We are more familiar with Jamestown, considered to be the first permanent English settlement in North America. Of more relevance to us, although less well known, is the other expedition led by fifty-eight-year-old George Popham. Well financed by Gorges, the expedition sailed from Plymouth, England, with instructions to establish a colony on the Maine coast. Popham is important because he was the leader of the first English colony in the area that would eventually be known as the province of Maine. Unfortunately, the colony would fail within a year.

Popham, who Gorges described as "an honest man, but old and of an unwieldly body," arrived with 120 English colonists on two ships, *Gift of God* and *Mary and John*, in mid-August 1607. The company included a dozen gentlemen, as well as soldiers, artisans and farmers. The settlers landed on a point of land at the mouth of the Kennebec River near present-day Phippsburg, ten miles south of Bath, Maine. The colonists hoped to trade for precious metals, spices and furs and use local timber to begin a shipbuilding industry.

George Popham was the nephew of a major financial backer of the colony. Sir John Popham was lord chief justice of England and a close friend of King James. Popham's second in command, Raleigh Gilbert, had an even more impressive pedigree. Gilbert was a nephew of Sir Walter Raleigh and the son of the great sixteenth-century English explorer Sir Humphrey Gilbert.

The colonists immediately began construction of a large star-shaped fort complete with ditches and ramparts, which they named Fort St. George. We know approximately what the original colony looked like from a map drawn by draughtsman John Hunt that showed eighteen houses, as well as a chapel, a guardhouse and storage buildings. Hunt's map is a story in itself. It was

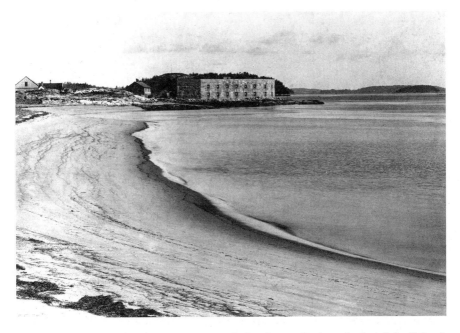

Fort Popham, Phippsburg. The fort was named after George Popham, leader of the ill-fated 1607 English colony. The fort is located at the mouth of the Kennebec River near the site of the original settlement. *Courtesy of Maine Memory Network.*

discovered in 1888 in the Spanish National Archives. Apparently, an English spy had sold it to the Spanish ambassador. Today, the map is regarded as the only known plan of the layout of an early English colony.

Popham and Gilbert made contact with a local tribe of Native Americans known as the Abenakis, a branch of the Algonquins. Popham wrote to the king that the Abenakis had assured him that there were "riches" in the area, but that was as far as they got. Further advances were rebuffed because the Abenakis were suspicious of closer contact. Memories of the recent Weymouth expedition, members of which had kidnapped several of their tribe and taken them back to England, were still fresh.

Because of their late summer arrival and the end of the growing season, the colony's settlers faced immediate food shortages. With little food available, a shipload of less enthusiastic colonists returned to England on the ship *Gift of God*. They left with a letter from Popham to King James in which the former clearly exaggerated the benefits of the colony: "The empire of your Majesty may easily be enlarged and the welfare of Great Britain speedily augmented in these parts." The forty-five men who remained survived feuding between

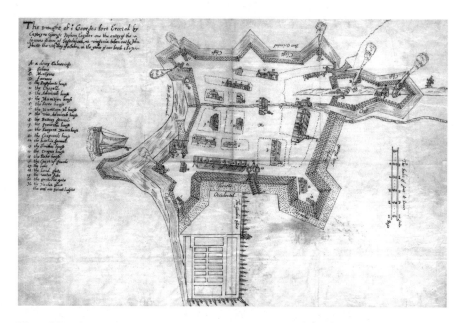

Map of Fort St. George drawn by John Hunt, a member of Popham's expedition. Recent excavations have confirmed the accuracy of much of the drawing. The map is the only known plan of an early English settlement. *Courtesy of Maine Memory Network.*

the two leaders, scurvy, fires in their homes and a very cold winter. As Gorges was to write later, "Our hopes were frozen to death."

In February 1608, the colony faced a major setback when George Popham died. As a result, twenty-five-year-old Raleigh Gilbert became president of the colony. Remarkably, Popham appears to have been the only colonist not to make it through the winter. This is in stark contrast to the Jamestown settlement, where we know that almost half the settlers failed to survive the year.

In the spring, a supply ship arrived at the settlement with news that Raleigh Gilbert's older brother had died and he was now heir to his family's estates. Gilbert departed, and the remaining settlers, having lost both their leaders, decided to return to England. The Popham Colony had lasted less than a year.

During the winter, the shipwrights in the company constructed a thirty-ton vessel called a pinnace, which they named *Virgina*. (The primary function of a pinnace was as a tender for larger vessels.) The little boat has the distinction of being the first ship built in Maine, and it set high standards for future Maine shipbuilders.

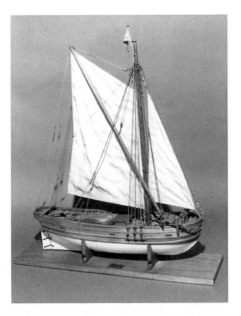

A model of the pinnace *Virginia*. A pinnace was a seventeenth-century sailing craft often used as a tender. *Virginia* was built in 1608, the first ship to be built in Maine. *Courtesy of Maine Maritime Museum, Bath, Maine.*

Virginia was filled with a cargo of furs and sassafras root and accompanied the *Mary and John* on its return voyage to England. The little ship turned out to be very seaworthy and crossed the Atlantic a number of times. A few years later, *Virginia* survived a brutal three-day storm that wrecked the flagship of the expedition heading for Jamestown. *Virginia* continued to make voyages up and down the coast of New England for the next twenty years until it was wrecked off the shore of Ireland while returning to England.

What we know about the Popham Colony is largely due to the efforts of Dr. Jeffrey Brain, a senior archaeologist at the Peabody Essex Museum in Salem, Massachusetts. Beginning in the early 1990s, Brain spent his summers excavating the area to verify the John Hunt map. The map, which was originally regarded skeptically by scholars, has provided valuable information about the colony, the first settlement in Maine.

At the start of the Civil War, the Union army began construction of Fort Popham on the Kennebec River at the entrance to Atkins Bay. Fort Popham was later occupied during the Spanish-American War and World War I. The fort is less than a mile from the original colony site. Today, most of the area is part of Maine's Popham Beach State Park, a popular beach and recreation area.

THE MISSIONARY: FATHER SEBASTIEN RÂLE

Father Sebastien Râle is one of the most controversial figures in the history of seventeenth-century Maine. Depending on whether you were French or English, he was either a saintly priest who became a martyr or a sinister "Black Robe" who was behind many of the Indian outrages on the frontier.

Sebastien Râle was born in France in 1657. He grew up in the France Comté section of Burgundy and, against his parent's wishes, became a Jesuit novitiate in 1675. He taught Greek and rhetoric at Nimes while he was completing his studies. In 1688, Râle became a full-fledged member of the Jesuit Order.

During the seventeenth and eighteenth centuries, the Catholic Church was fiercely combating the teachings of Martin Luther, John Calvin and other Protestant reformers who had criticized the practices of the papacy. This response by Catholicism was known as the Counter-Reformation, and the Jesuit Order, founded by Ignatius Loyola in 1540, was its spearhead. Catholic missionaries spread quickly across the globe attempting to stem the tide of Protestantism. At the same time, they tried to Christianize the native peoples with whom they came into contact.

In 1689, thirty-two-year-old Father Râle volunteered to spend the rest of his life in the New World. Thus began the career of one of the most prominent missionaries in New England. He arrived with Comte de Frontenac, the governor general of Quebec, or New France, as it was known in those days. Râle spent his first year among the Abenakis (a branch of the Algonquins) near Quebec before heading west to spend several years among the Native American tribes in present-day Illinois. By the time he left the Abenakis, however, this former teacher of Greek had already begun to study their language.

In 1693, Râle returned to live and work permanently among the Abenakis, who lived along the Kennebec River in central Maine. He would remain there until his death in 1724. In 1698, Râle built a small church or mission next to the fortified Indian village of Norridgewock. (The town of Norridgewock is located about five miles west of Skowhegan.) It was here that he taught the Abenakis some of the beliefs of Catholicism. Father Râle was what we would today call a "full-service" missionary for the little community. In addition to tending to spiritual needs, he also possessed skills as a carpenter, a farmer, a doctor and, as we shall see, a linguist.

In the next few years, this Jesuit missionary became so proficient in the Abenaki language that he began to compile an Abenaki-French dictionary. The manuscript that resulted from his studies is preserved in the Harvard College library. It is said that Râle was fluent in at least three dialects of Algonquian besides the Huron dialect of the Iroquois.

Father Râle was clearly getting his message across to the Abenakis. Mass was said every morning and vespers in the evening, both times in Abenaki. In a candid letter to his nephew, Râle wrote:

Colonial Maine

It is needful to control the imagination of the savages, too easily distracted. I pass few working days without making them a short exhortation for the purpose of inspiring a horror of the vices to which their tendency is strongest and for strengthening them in the practice of some virtue. My advice always shapes their resolutions.

Although Father Râle was highly regarded by the French and Abenakis, English settlers in the area became increasingly suspicious of the enterprising French missionary living at Norridgewock. The English tended to regard all Indians as savages who were incapable of conversion to Christianity. When violence occurred on the Maine frontier, it was assumed that Father Râle was the instigator.

When the War of the Spanish Succession (1702–13) broke out in Europe, the effects were quickly felt on the New England frontier, where the conflict was known as Queen Anne's War. In 1703, Massachusetts governor Joseph Dudley proposed that local tribes remain neutral. The Abenakis at Norridgewock rejected Dudley's suggestion, however, and joined a force of French and Indians in an attack on Wells in southern Maine. Father Râle was suspected of influencing the Abenakis, perhaps because the "heretic" Protestant English settlements were drawing ever closer to their village at Norridgewock.

Governor Dudley responded by literally putting a price on Râle's head. In the winter of 1705, a force of British soldiers was dispatched to seize Râle and torch the village of Norridgewock. The priest was warned of the attack, however, and fled with most of his papers. The frustrated English troops burned the chapel and sacked the village. Father Râle returned to Norridgewock a few months later, and by 1710 the chapel had been rebuilt.

In 1713, the Treaty of Utrecht ended the war in Europe and North America. In Massachusetts Bay, the Treaty of Portsmouth specifically ended hostilities between the Abenakis and the colony. At a meeting with Governor Dudley, delegates from the various Abenaki tribes swore allegiance to Britain as part of Dudley's effort to establish lasting peace between the Indians and the colonists. Sadly, as historian and novelist Francis Parkman wrote, "It is safe to say they did not know what the words meant."

Because of the almost continual fighting for the previous forty years, the New England frontier had became a virtual desert by the end of the war. Following the Treaty of Portsmouth, however, English settlers began to pour into the area. New villages were built and old ones repaired. The Abenakis viewed the advancing white frontier with alarm and accused the English of

encroaching on their hunting grounds. The English responded that they had bought the land fair and square. Unfortunately, each side had a different idea of what constituted land ownership. To Native Americans, the selling of land simply meant granting permission to hunt and fish. In addition to seeing their lands disappear, Native Americans also felt that they were being cheated in their exchanges with local fur traders.

With the apparent approval of Father Râle and other missionaries, braves began to raid the farms of the English settlers, killing their cattle and burning their crops. In 1717, Samuel Shute, royal governor of Massachusetts, attempted to calm the situation by hosting a conference of Abenaki leaders at Georgetown. Unfortunately, he only inflamed things when he declared, "Cooperation with the French would bring them utter ruin and destruction." To this, Father Râle responded, "Any treaty with the governor is null and void if I do not approve it, for I give them so many reasons against it that they absolutely condemn what they have done."

Râle was becoming a marked man because of his influence over the Abenakis. In January 1722, when most of the tribe was hunting, Colonel Thomas Westbrook and three hundred soldiers surrounded Norridgewock in an attempt to capture Father Râle. Again, the priest had been warned and escaped, but Westbrook found a strongbox among his possessions that contained letters implicating Râle as an agent of the French government. Included were promises of enough rifles and ammunition to drive the English from their settlements. Westbrook also found Râle's three-volume Abenaki-French dictionary, which was eventually given to Harvard College.

In 1723, Governor Shute departed for London, having grown weary of constant squabbles with the Massachusetts Bay Assembly over how to conduct hostilities with the Abenakis. (Most recently, and as revenge for the raid on Norridgewock, a group of braves had burned the coastal town of Brunswick.)

With Shute's departure, Lieutenant Governor William Dummer took control of the colony. In August 1724, Governor Dummer sent a force of two hundred militiamen under Captains John Harmon and Jeremiah Moulton up the Kennebec River. When they reached Norridgewock, the village was stormed and many of its defenders killed. Father Râle was shot in the head while reloading his musket. His body was mutilated and then scalped.

Sixty-seven-year-old Father Râle was buried beneath the altar where he had so often given Mass to the Abenakis. The 150 members of the tribe who survived the massacre headed north to live in Canada. Their departure marked the end of the tribe's existence in central Maine. Râle's death was

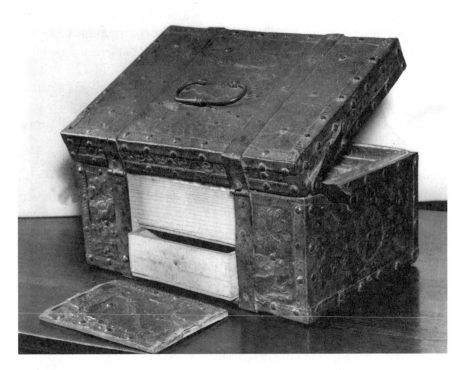

Father Râle's strongbox. In 1721, British troops raided the Indian village where Father Râle was living. He escaped, but this box containing his papers, including an Abenaki-French dictionary, was confiscated. Note the secret compartment. *Courtesy of Maine Memory Network.*

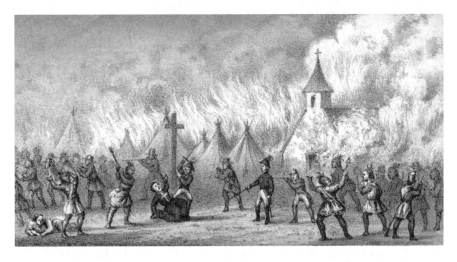

The death of Father Sebastien Râle, from an engraving done in 1856. Father Râle was a Jesuit priest who was killed by English soldiers in 1724. *Courtesy of Maine Memory Network.*

also a serious blow to the French presence on the Maine frontier, one from which they never recovered. Today, an eleven-foot obelisk marks Râle's grave in the town of Madison, Maine. Nearby, there is a road named after him that runs beside the banks of the Kennebec.

Father Râle remains a polarizing figure in the history of seventeenth-century New England. Revered by the Abenakis, he was considered a martyr who died for his faith. Some Indian prayers and a catechism still in use among the Penobscots and Passamaquodies are attributed to him.

To the English, Sebastien Râle was an opportunist who used Native Americans to suit his purposes. To quote Francis Parkman, "He did not die because he was an apostle of the faith, but because he was an active agent of the Canadian government." Maine author Louise Dickinson Rich was kinder: "Râle was fond of the Indians and deeply concerned with their welfare. He was just one of many missionaries working equally selflessly among the tribes, but he was the outstanding example of his kind."

THE FORTUNE HUNTER: WILLIAM PHIPS

William Phips was born in 1651 in a farmhouse next to the Kennebec River. The son of a gunsmith and the youngest of twenty-six children (all by the same mother), he grew up in Woolwich, Maine. Although he lacked formal schooling, Phips taught himself to read and write while studying to be a ship's carpenter.

Phips was an ambitious young man, and he soon became frustrated with the limitations of his life in rural Maine. When he turned eighteen, he decided to go to Boston in hopes of improving his situation. There, Phips met Roger Spencer, a merchant ship captain with an attractive, recently widowed daughter. After a whirlwind courtship, Phips married Mary Spencer, an event that would change his life dramatically.

Phips's father-in-law recognized William as a capable young man and in a few years gave him command of a ship that plied the trade routes to the West Indies. Phips rapidly became a successful merchant captain in his own right. By 1680, he had also become an accomplished Caribbean navigator.

While sailing in the Caribbean, Phips heard stories of Spanish treasure ships that had been lost at sea during storms. One intriguing tale was that of an entire fleet of sixteen galleons that had been sunk in a hurricane in

William Phips was a self-made man. He rose to become the first colonial governor of the province of Massachusetts Bay in 1692. *Courtesy of Emerson Baker, Salem State University.*

1643 after leaving Puerto Rico for Spain. Phips became fascinated with the idea of recovering the treasure, and after interviewing a number of local sailors he was able to estimate with a reasonable degree of accuracy where the fleet had sunk. Using his navigational skills, he calculated that it was near a reef in the proximity of the island chain of the Caicos and Turks, which are part of the Bahamas.

At this point, Phips realized that he needed considerably more financial backing for the salvage operation than he could ever get in colonial America, and so in 1682, he set sail for England. After a series of futile attempts to sell his idea to wealthy Londoners, he was finally able to arrange an audience with King Charles II. The king was intrigued by the idea and gave the enterprising Phips a royal commission, along with a frigate with which to search the waters around the wreck. When his first salvage attempt failed, the undaunted Phips returned to England and persuaded the Duke of Albemarle to outfit a second expedition.

In 1687, Phips literally struck gold when he recovered £300,000 worth of Spanish coin from *Almiranta* off the shore of Haiti. One-tenth of the treasure went to the new king, James II; one-sixteenth to Phips; and the rest to his investors. His share of the treasure was £16,000, which made him not only rich but also very prominent. As a reward for his efforts, King James knighted Phips and appointed him sheriff of New England under Governor Andros. Altogether, it was a remarkable achievement for a poor boy from the province of Maine.

In 1690, Phips, whom we are told had become rather self-important, was appointed commander of an expedition against French-held Nova Scotia. With a fleet of seven ships and an army of 450 men, Phips and his forces swiftly captured the Acadian capital of Port Royal (now Annapolis Royal). His army pillaged the remainder of Acadia, and Phips returned

to Massachusetts to enjoy his triumph. Perhaps all of the acclaim went to Phips's head, because his next expedition was less well organized.

Giddy with the success from the Port Royal venture, and barely two months after returning from Nova Scotia, the self-proclaimed conqueror of French North America decided to launch an attack on the French citadel of Quebec. Late in the summer of 1690, Phips set sail for the St. Lawrence River with a fleet of thirty-two ships and two thousand men. When the armada arrived in front of Quebec late in October, it was clear that it was not ready to begin a protracted siege, nor was it prepared to face the Canadian winter. After a short siege, a disappointed Phips reluctantly reembarked his forces and returned to Boston.

Stopping only briefly in Boston, Phips sailed immediately for England, where he hoped to raise support for another attack on Canada. Although his attempt failed, he ran into a familiar face. Increase Mather, also from Boston, was an influential colonial official and a well-known Puritan minister. Mather was in London to lobby for a royal charter for Harvard (another of his many jobs was president of the college). The two men were friends, and through the influence of Mather, Phips was appointed governor of Massachusetts by William and Mary, the new king and queen of England.

It should be noted that the charter that the monarchs granted to Mather and Phips represented a major change in the governing of the colony. The 1692 charter granted sweeping home rule for Massachusetts and established a legislature that gave the vote to all freeholders. (Previously, only men who were members of a congregation were allowed to vote.) The charter added Maine to the Massachusetts Bay Colony and combined it with the Plymouth Colony. Finally, the charter allowed the colony to remove and arrest the unpopular previous royal governor, Edmund Andros.

Phips returned to Massachusetts in 1692 and was immediately caught up in the frenzy of the Salem witch trials. The situation was awkward, since Increase Mather's son, Cotton Mather, was one of the moving forces behind the trials. Furthermore, Phips attended the Old North Church in Boston, where both Mathers were pastors. For several months Phips was uncertain how to proceed. At first, he appointed a commission to try those accused of witchcraft. Then, when his wife, Mary Phips, was accused of being a witch, he ordered the trials to stop and prohibited the further arrest of witches. In 1693, he pardoned those accused witches who were still in prison.

In most ways, however, it was apparent that Phips was ill suited for the job of governor. His rough style and lack of political acumen brought him

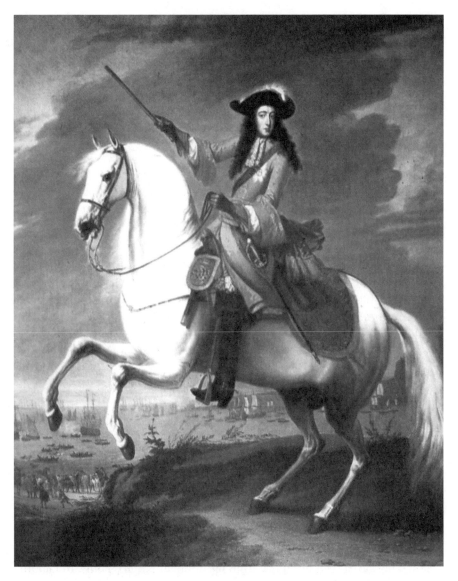

William III was the king of England who appointed William Phips to be governor of the province of Massachusetts. King William and his wife, Mary, became co-sovereigns of England in 1688. *Author's collection.*

into conflict with many important people, including Lieutenant Governor Stoughton and the governor of New York. There are many stories of his fearful temper. At one point, he brutally attacked the king's customs collector, beating him with his fists and cane.

In 1694, after two turbulent years, Phips was summoned to London to answer charges of "maladministration." Viola Barnes, in *PHIPPIUS MAXIMUS*, lists three transgressions: Phips was autocratic toward his opponents in the Massachusetts legislature, he was relentless in accepting bribes at every opportunity and he refused to cooperate with the governor of New York in defending New England against the French and Indian menace. Phips was in London preparing his defense when he died of the "New Fever," apparently the flu, on February 18, 1695, at the age of forty-four.

History has given us a mixed verdict on this self-made man. British historian John Fortescue wrote that he was "ignorant, brutal, covetous and violent…His education was elementary, his mental endowment was limited and he was fond of boasting of his self-made career. He owed everything to his luck in recovering treasure from a sunken vessel."

And yet, even the critical Fortescue admitted, "He had a flair for making himself attractive to powerful and influential men; and, even more important, the ability in the first place to spot them." To this, his minister Cotton Mather added, "I never saw him do any evil action or heard him speak anything unbecoming a Christian."

One cannot deny Phips's accomplishments. The poor kid from Maine, youngest of twenty-six children, was knighted by the king of England and rose from nothing to become the first colonial governor of the Massachusetts Bay Colony.

THE CITIZEN SOLDIER: WILLIAM PEPPERRELL

William Pepperrell was a man of many talents, even for his day. He was a merchant, a soldier and a statesman. He was named a baronet for his exploits in leading the successful Louisbourg expedition in 1745, the first American to receive a title. Finally, unlike other Mainers who rose to prominence in the colonial period, he did not move from his home in Kittery Point. In fact, the Lady Pepperrell house, built for his wife after his death, can be seen today.

Pepperrell was born into an upwardly mobile colonial family in 1696. His father, William, who had begun life as a fisherman's apprentice, became a successful shipbuilder and fishing boat owner. As a young man, he had the good fortune to marry the daughter of a prosperous Kittery merchant. William, the couple's only son, was taken into the family business as a youth and immediately displayed the intelligence, energy and good nature that were to serve him well throughout his life.

By the 1720s, the largely self-educated Pepperrell had expanded his father's ventures into one of the most prosperous mercantile operations in New England. Pepperrell ships carried lumber and fish to Europe and the West Indies and returned with goods that were sold throughout New England. Through shrewd investing of his profits, Pepperrell soon owned almost the entire townships of Saco and Scarborough in the province of Maine.

Pepperrell married well. His business affairs often took him to Boston, where he met Mary Hirt, whom he married in 1724. Mary was the granddaughter of Samuel Sewall, a well-known Boston judge. Sewall is best known for his role in the Salem witch trials. It is interesting that during this period Pepperrell showed his liberal side by becoming a staunch opponent of slavery, thus making him an early colonial abolitionist.

As a young man, Pepperrell joined the local militia, and by the age of thirty he had risen to the rank of colonel. This promotion was an important step in his career, since he was now commander of the entire Maine militia. When the War of the Austrian Succession broke out in 1745, Pepperrell's experience as a militia colonel would lead to his command of the colonial forces that were to attack the French fortress at Louisbourg on Cape Breton Island.

Because of his wealth and growing military prominence, in 1726 Pepperrell was elected as the representative from Kittery to the Massachusetts General Court. When his father died in 1734, Pepperell inherited his estate, making him one of the richest men in New England. Although he had no formal legal training, Pepperrell was appointed chief justice of the Massachusetts Court of Common Pleas, a position he held from 1730 until his death in 1759. He also served on the Governor's Council from 1727 to 1759.

The climactic moment of Pepperrell's career was rapidly approaching. In 1740, yet another war had broken out in Europe. Originally, it was known as the War of Jenkins's Ear, stemming from an incident that occurred in the Caribbean when a Spanish officer chopped the ear off Robert Jenkins, an English merchant suspected of being a pirate. The furious Jenkins was told to "take that to your king," who at the time was George II. When Jenkins allegedly displayed the severed ear in Parliament, war between England and Spain broke out. Spain was getting the worst of it until 1744, when France joined the Spanish against the British. In the American colonies, this would be known as King George's War.

The primary colonial objective in North America was the French citadel at Louisbourg on Cape Breton Island. In the spring of 1745, Pepperrell gathered volunteers, whom he financed and trained for the campaign. In April of that year, he led four thousand men, one-third of whom were from

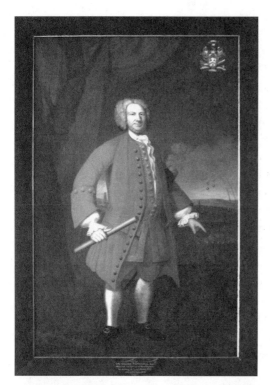

Left: William Pepperrell was a prosperous merchant, soldier and statesman from Kittery Point, Maine. Pepperrell would become one of the wealthiest men in New England. *Painting by Ulysses D. Tenney, courtesy of Portsmouth Athenaeum.*

Below: John Brook's engraving of the landing of the New England forces in the expedition against Louisbourg. William Pepperrell was first made a baronet following a successful siege. *Courtesy of Anne S.K. Brown Military Collection, Brown University Library.*

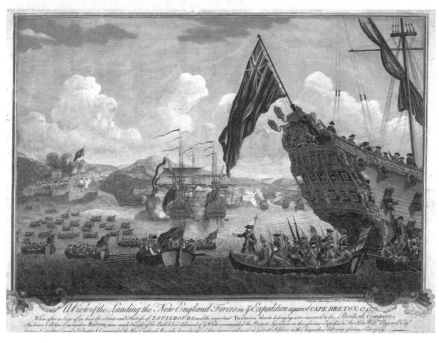

Maine, in a combined land-sea operation against what was considered to be the strongest fortification in North America. As Benjamin Franklin remarked to his brother, who lived in Massachusetts, "Fortified towns are hard nuts to crack; and your teeth are not accustomed to it."

The siege itself had elements of a comic-opera affair. The good-natured Pepperrell was well liked by his troops, but there was little discipline. The New Englanders advanced in disorderly fashion. One soldier described it thusly: "Everyone did what was right in his own eyes." For the French, Louisbourg turned out to be a trap. The fortress had been built to repulse an attack from the sea but not from the land. Furthermore, by 1745 much of the fortress was in disrepair. Many of its cannons, particularly those facing the land, were not mounted, leaving that part of the fort less protected than the seaward side.

Bombardment became the order of the day as the siege dragged on. With the walls crumbling and ammunition and supplies running low, the Americans inched closer. When a relief ship from France was driven off, Louis du Pont Duchambon, commander of the fortress, reluctantly agreed to surrender. After six weeks, "the strongest fortress in North America" surrendered on June 16, 1745.

Paris was stunned that an army of provincial militia could take the mighty citadel. London, of course, was overjoyed. The English desperately needed a victory since they had recently been defeated by the French at the Battle of Fontenoy in present-day Belgium. Honors and tributes were heaped on the triumphant Americans. In 1746, Pepperrell was named a baronet for his exploits, the first native-born American colonial to be so honored. Nathaniel Hawthorne, writing in 1833, hailed him as "the mighty man of Kittery." Everywhere he went, Pepperrell was hailed as "the hero of Louisbourg." Even Voltaire was impressed, commenting that it was among "the most remarkable events in the reign of Louis XV." In 1749, Pepperrell was invited to England to be received by the king. Simultaneously, he was honored by the City of London.

There was a sour note that followed the victory. At the Treaty of Aix-la-Chapelle in 1748, Louisbourg was returned to France in exchange for Madras being returned to England. The fact that twelve hundred Americans had died in the siege, including many from Maine, was not forgotten. New Englanders felt betrayed. This contributed to growing resentment toward Great Britain that was to climax in the American Revolution.

The last ten years of Pepperrell's life continued to be eventful. After the war, he sold his business interests and lived off the revenue from his extensive landholdings, which were chiefly in Maine. In 1753, he was appointed to the commission that negotiated a treaty with the Maine Indians. The Seven Years'

In the mid-eighteenth century, Louisbourg was considered a virtually impregnable French fortress on Cape Breton Island. In 1745, it surrendered to American colonial forces led by William Pepperrell. *Author's collection.*

War, known in America as the French and Indian War, broke out in 1756. Pepperrell, now a major general, was ordered to raise a regiment of men and defend the Maine and New Hampshire frontier. As the war raged on, Pepperrell continued to raise and train troops for the Massachusetts colony.

In 1757, Pepperrell was made acting governor of Massachusetts and was promoted to the rank of lieutenant general in the British army, the first American to reach such a level. Unfortunately, ill health forced him to retire from the army. When he died at his home on Kittery Point on July 6, 1759, he was considered to be the wealthiest man in New England.

Nathaniel Hawthorne wrote of Pepperrell:

> *He has a double claim to remembrance. He was a famous general, the most prominent military character in our ante-Revolutionary annals; and he may be taken as the representative of a class of warriors peculiar to their age and country, a true citizen-soldier.*

William Pepperrell left no son to carry on his name, so he adopted his grandson, William Pepperrell Sparhawk, as his heir. Sparhawk inherited the bulk of his grandfather's wealth and succeeded to his baronetcy. Sparhawk, however, was an ardent Loyalist, and on the eve of the American Revolution he fled to England, where he remained for the rest of his life

Part II

MAINE DURING THE
AMERICAN REVOLUTION

O ne does not usually think of Maine as playing an important part in the American Revolution. Although it was not one of the original thirteen colonies, the province of Maine was involved in the War for Independence a number of times. This occurred especially at the beginning of the war. In June 1775, the first naval battle of the Revolution took place in distant Machias and resulted in an American victory. The British subsequently attempted to strike at Machias several times in the next few years, but each time they were turned back.

In response to the Machias defeat, a British fleet of six ships sailed out of Boston with orders from Admiral Graves to "make the most vigorous efforts to burn the towns and destroy the shipping in the harbors." The admiral's list of targets included Falmouth (Portland) and, of course, Machias. The shelling of Falmouth began on October 18, 1775, and continued for eight hours. Using heated cannonballs, the British forces systematically destroyed three-quarters of the town. Two days later, the town was still burning. Miraculously, no one was killed, but Falmouth's economy was in ruins. The raid's effect, however, only strengthened the resolve of the population for independence.

The third event in 1775 occurred late in the fall when Benedict Arnold led a force of one thousand mostly Maine men up the Kennebec River and across northern Maine in what turned out to be a futile attack on Quebec. For the next four years, things were relatively quiet until the British decided to put a stop to the privateering that was threatening their base at Halifax, Nova Scotia. The result in 1779 was the disastrous Penobscot Expedition.

THE FIRST SEA VICTORY:
JEREMIAH O'BRIEN AND THE BATTLE OF MACHIAS

It wasn't much as far as sea battles go, but the Battle of Machias is generally regarded as the first naval engagement of the American Revolution. It was, however, the beginning of a much larger contest for the seas that clearly favored the English.

On one side was the British navy with 130 ships of the line, the battleships of the day. Arrayed against them, the Americans had a handful of converted merchant vessels. Closer examination, however, reveals that many of the big British ships suffered from poor construction or neglect. When the Revolution broke out, Great Britain had approximately 40 ships of the line that could be considered battle ready. These, along with their support ships, were stretched to the limit in an effort to blockade the American coastline.

Machias is in the far corner of Down East Maine, twenty-five miles from the Canadian border. The town was settled in 1763 by immigrants, mostly from Scarborough, Maine, seeking new sources of timber with which to supply (ironically) masts for the British navy. In addition to the lumber industry, there was a little subsistence farming. That was the extent of the Machias economy at the start of the Revolution.

The town was composed of approximately eighty families and several dozen single men, all of whom were getting very hungry by the late spring of 1775. Only the arrival of several ships during the winter kept the town from literally starving. When the beleaguered residents heard about the Battles of Lexington and Concord, however, they decided they didn't want their lumber to be used to help the British war effort, whether it was masts for ships or timber for barracks in Boston. In defiance of the king and in support of the Revolution, a liberty pole was erected. (A liberty pole was frequently erected in town squares of patriotic villages and towns before and during the Revolution. There was often an ensign or a cap placed at the top of the long pole.)

Meanwhile, in Boston a wealthy merchant from Machias named Ichabod Jones, knowing how desperate his town was for food, agreed to take supplies to the stricken village. (Actually, he had only lived in Machias for a year.) The crafty merchant planned to exchange the needed provisions for Machias timber that the British needed to build barracks in Boston. Jones was an ardent Loyalist, which made him popular with the British authorities in Boston but equally unpopular with American Patriots up and down the coast. The *Providence Gazette* called him "an infamous Tory," which was one of the more polite descriptions of this conniving man.

The Burnham Tavern was built in 1770 and today is a historical museum that contains mementos from the Battle of Machias. In 1775, the tavern's taproom was where the decision was made to oppose British forces. *Courtesy of Burnhan Tavern Museum, Machias, Maine.*

Jones was no fool, however, and he requested that an escort ship accompany the two supply vessels, *Unity* and *Polly*, that he planned to sail to Machias. And so on June 2, 1775, a small British warship, the armed sloop *Margaretta*, sailed into Machias Harbor under the command of twenty-five-year-old midshipman James Moore. *Margaretta* was not heavily armed, but the British figured that its fourteen swivel guns (small cannons) would be enough to intimidate the local Patriots.

Midshipman Moore was irate when he arrived in Machias and saw the liberty pole in the middle of the square. He considered the pole an affront to the Crown and ordered it removed immediately or else he would bombard the town. Ichabod Jones made the situation worse by declaring that only those citizens who agreed to sell him lumber would be allowed to trade for the food he was carrying. Angry citizens met at the Burnham Tavern and refused to be bullied by either threat. They not only refused to remove the pole but also plotted to capture Moore and Jones the next day when they were in church.

It is time to introduce thirty-one-year-old Jeremiah O'Brien, who, along with Benjamin Foster, was to play a prominent role in the events that followed. O'Brien's father, Morris, emigrated from Ireland and settled in Scarborough,

Maine. In 1765, he moved to Machias, where he and his family established themselves in the lumber business. Jeremiah was the oldest of six O'Brien sons. As the crisis with *Margaretta* escalated, he was naturally looked to for leadership.

On Sunday morning, June 11, as Jones and Moore were sitting in church, they heard the loud voices of several dozen men outside the building. In a scene reminiscent of a Road Runner cartoon, Jones and Moore jumped out the window and fled from the church, with a mob, including the six O'Brien brothers, literally nipping at their heels. Jones disappeared into the woods for several days before he was captured. Moore and his second officer, James Stillingfleet, barely made it back to *Margaretta*.

Frustrated in their efforts to stop Moore, a group of men boarded Jones's sloop *Unity*, which was docked at the town wharf, and removed its remaining supplies. Another group rowed out to *Polly* and attempted to tow it to shore. It ran aground, probably because the tide was out. Moore made the next move when he maneuvered *Margaretta* next to *Polly* in an attempt to recover it. After an exchange of gunfire, however, Moore withdrew and sailed downstream, where he anchored for the night.

Onshore, a throng of angry citizens, who by now considered themselves to be the Machias chapter of the Sons of Liberty, chose Jeremiah O'Brien as captain of the captured sloop *Unity*. Benjamin Foster meantime took a group of men upstream to East Machias, where they commandeered a small local schooner, *Falmouth Packet*. They armed themselves with whatever they could find, including swords, pitchforks and axes, and set off after *Margaretta*, which by now was heading downriver toward Machias Bay.

The Battle of Machias took place the next morning, June 12, 1775, in Machias Bay. The total number of men involved is difficult to judge, but *Unity* appears to have had about thirty men onboard, and Foster had at least twenty on his ship, *Falmouth Packet*. *Margaretta* had a crew of twenty, but the ship was "a very dull sailor," and the two American vessels soon overtook it.

After an exchange of gunfire, *Unity* pulled alongside *Margaretta*, and the American crew, led by the O'Brien brothers, stormed aboard the British ship. When *Falmouth Packet* pulled up on the other side, *Margaretta* was trapped. The British sailors fought bravely, but they were outnumbered by more than two to one. With their assortment of axes and pitchforks, the Americans had the advantage in the hand-to-hand combat that followed. Once the British sailors had discharged their pistols, they had no time to reload and were forced to surrender. The battle was over in less than an hour.

Midshipman Moore was badly wounded at the beginning of the fight and was taken below. He refused to give up the ship, saying that "he preferred

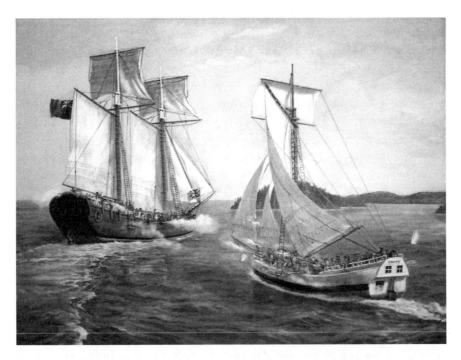

The 1775 battle between the British sloop *Margaretta*, on the left, and the American vessel *Unity*, on the right. This was the first naval engagement in the American Revolution and resulted in an American victory. *Painting by Robert Goodier hanging in the Machias Savings Bank, Machias, Maine.*

death before yielding to such a set of villains." His second in command, midshipman Stillingfleet, surrendered the vessel when it was obvious that the battle was lost. Moore was taken ashore and died the next day in the house of Ichabod Jones, who was still hiding in the woods.

Given the number of shots fired, casualty numbers were light on both sides. Some sources say that two Americans were killed and three wounded; others say that three Americans were lost and nine were wounded. As many as ten sailors from *Margaretta* may have been killed and an equal number wounded.

The jubilant Americans transferred the guns of *Margaretta* to *Polly* and renamed it *Machias Liberty*. Jeremiah O'Brien assumed command of the little fleet (which now also included *Unity*). Fearing retaliation from the British navy in Boston, the Town of Machias requested help from the Provincial Congress. In the meantime, Captains Jeremiah O'Brien and Benjamin Foster cruised the coast of Maine, capturing several more British vessels during the next few months. The British armed schooner *Diligence* was taken without a fight near Bucks Harbor, adding strength to O'Brien's growing fleet.

On June 26, 1775, the General Court of Massachusetts passed the following resolution:

> *That the thanks of this Congress be, and they are hereby given to, Capt. Jeremiah O'Brien and Capt. Benjamin Foster and the other brave men under their command, for their courage and good conduct in taking one of the tenders belonging to our enemies and two sloops belonging to Ichabod Jones, and for preventing the ministerial troops being supplied with lumber.*

The British continued to be frustrated by the actions of O'Brien and his little fleet. He and Benjamin Foster continued to patrol the coast of Maine, and during the course of the next year, the two captains frequently intercepted merchant ships supplying the British army in Boston. In 1776, Admiral Graves (the British admiral in Boston) gave orders to "proceed and reduce Machias." The attack was decisively repulsed. As already noted, the burning of Portland in October 1775 is considered to have been retaliation for the loss of British ships and men at Machias. One British officer is reported to have said, "Those damned rebels at Machias were a harder set than those at Bunker Hill."

Thus, the "Lexington and Concord of the sea" ended in an American victory. As James L. Nelson writes in *George Washington's Secret Navy*, "For (admiral) Samuel Graves the loss of twenty prime seamen was a much greater calamity than the loss of an insignificant schooner. For the people of Boston, the worst of the loss was the two shiploads of firewood."

In 1776, O'Brien and his brothers launched *Hannibal*, a twenty-gun sloop, which they used for privateering. In 1780, however, two British frigates caught *Hannibal* while it was cruising off the coast of New York. O'Brien was imprisoned for six months on *Jersey*, an infamous British prison hulk in New York Harbor. (Reportedly, more Americans died in British prison ships than in all the battles of the Revolutionary War.)

O'Brien was transferred to England and languished in the Mill Prison for several months. His escape, however, was vintage O'Brien. He concealed a set of respectable clothes in his cell until he felt the moment was propitious to escape. He then washed, shaved, put on his good clothes and walked out of prison, stopping at the warden's house for a drink before taking a boat to France.

After the Revolution, O'Brien returned to America. He lived with his brother, Joseph, in Brunswick for a while before returning to Machias,

where he was appointed federal customs collector. He held the position until his death in 1818.

Five ships in the United States Navy, including a World War II Liberty ship, have been named USS O'Brien in his honor.

THE GUIDE: REUBEN COLBURN AND THE BENEDICT ARNOLD EXPEDITION

We were to traverse a trackless wilderness intercepted by ponds, swamps and morasses, exposed also to almost continual hunger and at an inclement season, over mountains well covered by snows.
—George Morrison, expedition member

His was not a famous name, but next to Benedict Arnold, the most important member of Arnold's Quebec Expedition was a Maine shipbuilder named Reuben Colburn. The expedition of eleven hundred men included some well-known personages like Aaron Burr, Henry Dearborn and Daniel Morgan who trekked with Arnold across three hundred miles of wilderness to invade Canada. As the following story illustrates, however, Arnold's indispensable man was Reuben Colburn.

In 1761, Colburn, his seven siblings and their parents were among the first to move into the Pittston/Gardinerston (now Gardiner) area on the Kennebec River, a few miles south of present-day Augusta. The Colburn family sailed from Dracut, Massachusetts, where their great-great-grandfather, who emigrated from England in 1635, had settled.

The History of Gardiner informs us that "Colburn received 250 acres of land on the eastern side of the river" on which he built a sawmill, a brickyard, a boatyard and a gristmill to establish a livelihood for himself and to provide arriving settlers with materials. To quote Mark York, Colburn's grandson seven generations removed, "Ships built at the site by Colburn brought supplies from all over the world to the growing colonies, hence promoting American economic strength when the country was in its infancy." By 1765, Reuben and his brothers had completed an impressive two-story house for his family. The house built by Colburn still stands on a bluff overlooking the Kennebec River and is on the National Register of Historic Places.

Colburn was obviously a man of considerable energy, as well as strong convictions. One story, which may be apocryphal, is that every Saturday in the summer he would paddle his wife, Elizabeth, and their ten children thirty-five miles downriver by canoe to Georgetown to attend church.

As relations deteriorated between England and the American colonies over the next decade, Colburn joined and then took command of the local committee of safety. Following the Battle of Bunker Hill in June 1775, he went to Boston, where he met George Washington, who had recently been appointed commander of the Continental army. When Colburn heard about Benedict Arnold's plan to attack Quebec, he offered to supply the expedition with scouts, maps and boats. Washington, who had already recognized Colburn's abilities, immediately accepted his offer.

The idea of attacking Canada had been in Washington's mind for some time. The feeling was that the province of Quebec would fall easily because Canadians disliked the British almost as much as the Americans did. This opinion was along the same lines as the British thinking that American Loyalists would actively join them to defeat the rebels. Needless to say, both sides were to be disappointed, as a majority of both groups remained neutral.

Washington envisioned a two-pronged attack. One prong would strike Montreal from the south by proceeding up Lake Champlain and the Richelieu River. The other would constitute a surprise attack across the wilds of northwest Maine, hitting Quebec from the east. Although it was a gamble, the plan had appeal, since the invaders were unlikely to be detected until the last minute. The hope was that the simultaneous attacks would force the British to divide their limited forces, resulting in the capture of at least one of their major towns.

In August 1775, the thirty-five-year-old Colburn made three trips on horseback from his home in Maine to Cambridge, where planning for the Quebec campaign was underway. Colburn was questioned closely regarding logistics, intelligence and provisions for the expedition.

Washington charged Colburn with a formidable task, and it was one that needed to be completed quickly, since autumn was fast approaching. Colburn raced home to Pittston in two days to get started. Benedict Arnold's instructions were as follows:

> *You are to receive forty schillings lawful money for each Batteau, with the oars, paddles, and setting poles included; out of which you are to pay the artificers & for all the provisions, nails etc. they shall expend. Given at Headquarters at Cambridge this day of September 1775.*

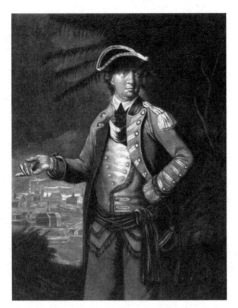

In 1775, Benedict Arnold was given command of an expedition to attack Quebec. Arnold led eleven hundred men across the wilderness of northern Maine in an unsuccessful assault on the city. *Courtesy of Library of Congress, Prints and Photographs Division.*

Colburn was also directed to provide men to accompany the army and make needed repairs along the way. With the exception of the twenty pounds Washington paid him in advance, the shipbuilder from Maine was never reimbursed for his expenses.

As quartermaster for the expedition, Colburn faced many problems, the most important of which was the absence of seasoned wood with which to build the bateaux. Because of this, he had to cut green pine, which tended to shrink and crack as it dried. To put it another way, in a little over two weeks Colburn had to cut twenty thousand board feet of long, wide boards and fashion them into two hundred bateaux. (A bateau is a shallow-draft, flat-bottomed boat that was used extensively on the rivers of colonial North America.) Another of Reuben's problems was labor. Many of the local population were British sympathizers. How would they respond?

Arnold marched his troops to Newburyport, where they boarded eleven smelly fishing vessels and headed for Maine. In two days' time, the transports, filled with now seasick soldiers, arrived at the mouth of the Kennebec River. It took a few more days for the transports to work their way up the river to Colburn's house at Pittston, beyond which the river becomes too shallow for large ships to navigate.

When Arnold and his men, including nineteen-year-old Aaron Burr, arrived on September 20, 1775, work on the bateaux was virtually finished. In a little over two weeks, the Maine shipbuilder had performed a logistical miracle. Although the boats were smaller than what Arnold had wanted, Colburn had also collected guides, supplies and maps and had assembled a team of carpenters ready to accompany the expedition to make emergency repairs.

Arnold spent the night in the Colburn house, which ever since has been known as "the house where Benedict Arnold slept." (He is reported to have used the upstairs bedroom on the southwest corner.) The next morning, an irate Arnold ordered twenty more boats to be built before he could move his army upriver.

In fairness to Colburn, Arnold and Washington had been vague as to the size of boat they wanted, and Colburn had simply provided them with what was currently used on Maine rivers. Nevertheless, the extra twenty bateaux were built while the army waited for ten days. As James L. Nelson wrote in *Benedict Arnold's Navy*, "One of the American Revolution's most extraordinary feats of endurance, courage, perseverance and leadership was about to get underway."

Colburn followed this small armada up the Kennebec River with a crew of carpenters, repairing the bateaux as needed (which was frequently). There was a difficult portage at the Skowhegan falls, where at one point Arnold lost his temper and berated Colburn for "the heavy and bad construction of the batteau." By late October, the army had reached "the Great Carrying Place," where, in a blinding snowstorm, the soldiers dragged their four-hundred-pound bateaux across a series of bogs and ponds from the Kennebec River to the headwaters of the Dead River. By this time, the exhausted army men, and their many camp followers, were literally starving (many actually died) and were reduced to eating their dogs, shoes, shot pouches and even bark from trees.

If Reuben Colburn was Benedict Arnold's indispensable man, then Colburn had his own in his faithful Abenaki companions, Sabatis and Natanis. They were invaluable in scouting the route ahead each day, and at one point they rescued the army when they were lost in the great Megantic Swamp at the Canadian border.

Benedict Arnold led his ragged army across Lake Megantic and down the Chaudiere River to the St. Lawrence. We know that at the "Chain of Ponds," just before the Canadian border, Colburn left the army and began the long trek back to Pittston. He resumed his shipbuilding and lumber business while remaining an ardent Patriot for the rest of the Revolution. After the war, Reuben was active in local politics, and from 1783 to 1789 he was a representative to the Massachusetts General Court. When the question of statehood for Maine was first raised, Colburn voted in the affirmative, but the measure was defeated.

For the remainder of his life, Colburn continued to press Congress to reimburse him for the expenses he had incurred building the bateaux and

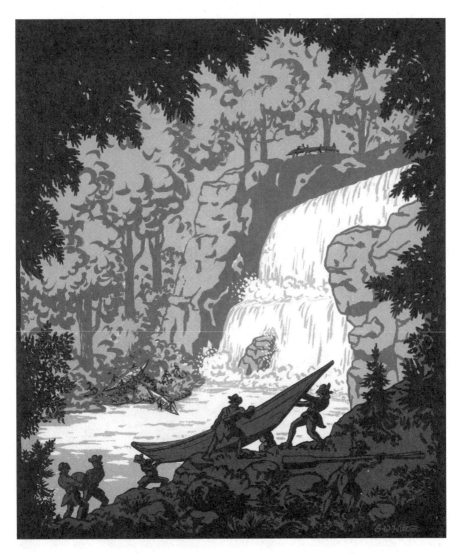

The portage around the falls at Skowhegan. "The falls are of an astonishing height and exhibit an awful appearance." *From Stockings's diary. Painting by S.W. Hilton. Courtesy of Arnold Expedition Historical Society, Pittston, Maine.*

equipping Arnold's expedition. At one point, General Henry Dearborn, who as previously mentioned had served with Arnold, testified to the validity of the claim. In 1824, however, Congress refused to approve payment, largely on the grounds that since so much time had elapsed and the records had been lost, the claim was doubtful. Colburn, meanwhile, had died in 1818 at the age of seventy-eight.

Carrying the bateaux over the Height of Land. "We proceeded slowly by hauling and pushing and using ropes in one case and setting poles in another." *From Forbes's diary. Painting by S.W. Hilton. Courtesy of Arnold Expedition Historical Society, Pittston, Maine.*

The historical novelist Kenneth Roberts likens the Arnold Expedition to Hannibal's crossing of the Alps, which is not a bad comparison. Like Hannibal, Arnold had to lead his men across brutal terrain to reach his objective. The six hundred men who survived the trek arrived at the St. Lawrence in November and looked uneasily across the river at the fortress that was known as "the

Gibraltar of America." After a six-week siege, they stormed the city on New Year's Eve 1775 and were repulsed with heavy losses.

Benedict Arnold's country owes him more than they will ever liquidate; and his defects can never obliterate the solid services and ample abuse which preceded it.

—*J.F. Schroeder, The Life and Times of Washington*

THE DISASTER: THE PENOBSCOT EXPEDITION

At the tip of the Bagaduce Peninsula in the northeast corner of Penobscot Bay sits the town of Castine. The town has had a tumultuous history that extends back to the early seventeenth century, making it one of the first settlements in North America. At various times, the French, Dutch and English have occupied colonial Castine. In the 1760s, at the end of the French and Indian War, the open lands along the Maine coast attracted hundreds of settlers from New England, especially Massachusetts. The result for the Castine area was the beginning of a fishing economy, as well as a new source of timber for the British navy.

In the spring of 1779, the British were still smarting from their most recent failure to subdue Machias two years earlier. In June, British troop transports, escorted by three small warships under the command of General Francis McLean, landed a force of seven hundred men on the Bagaduce Penninsula. The plan was to establish a base from which to oppose American privateer vessels that were operating along the Maine coast. Perhaps they would even get another chance to strike at Machias.

Using local labor, McLean proceeded to construct a modest set of earthworks, which he named Fort George. One British soldier described it as "so feeble a bastion that a soldier could jump over it with a musket in each hand." The project continued for four weeks until, in late July, an American fleet suddenly appeared in Penobscot Bay. The Massachusetts General Court (the legislative body) was not about to give up control of central Maine to the British without a fight.

General Solomon Lovell and Commodore Dudley Saltonstall were given command of an expeditionary force. Lovell was a courageous soldier, but he lacked field experience. Saltonstall was an experienced naval commander, but his subordinates complained of his "rude, unhappy temper." He was from Connecticut and had been appointed by Congress,

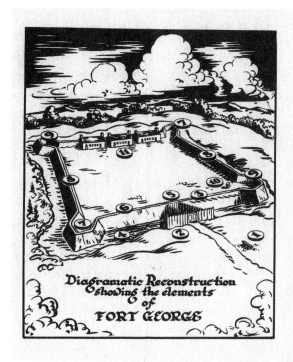

DIRECTORY OF FORT GEORGE MEMORIAL

1. Cannon
2. Palisade: A row of long pointed stakes for defense.
3. Fraising: Large stakes driven into rampart near the top, close together and sharply pointed. Extended horizontally half way across moat.
4. Moat: A ditch, here dug down to ledge.
5. Original Gateway facing the town.
6. Ramparts: These were six feet wide on top, and level.
7. Magazine: Built in this bastion. This one rebuilt in 1962. Over the original were layers of logs and all covered with earth.
8. Curtain: The ramparts connecting the flanks of the bastion.
9. Bastion: One on each corner, has two faces and two flanks.
10. Monument to British occupations.
11. Barracks: The British built a row of barracks parallel to northwest curtain.

Castine is an historic town and there are many points of interest worth visiting to the limit of time available to you. Some of these include:

1. The Wilson Museum—history, archeology, geology. Open daily 2-5 p.m. Summer.
2. Fort Madison, captured by British in War of 1812.
3. State of Maine Maritime Academy. Youth trained for merchant marine. Open daily 10-12 and 2-5.
4. Old Meeting House (1790) one of oldest in Maine. Unitarian. Revere Bell.
5. Old Courthouse—present library site.
6. Several old houses as far back as 1765. Not open to the public.

The Maine Department of Parks & Recreation hopes that your visit to Fort Kent Memorial has been pleasant. This folder is intended to make your visit more interesting and serve as a memento of your visit.

A diagram of Fort George, which was built on the highest point of land in Castine. The fort was under attack by American forces when the arrival of a British fleet forced the Americans to withdraw. *Courtesy of Castine Historical Society, Castine, Maine.*

which, as we shall see, would be significant. Other notable American officers included experienced general and second in command of the army Peleg Wadsworth, Henry Wadsworth Longfellow's grandfather. Another familiar name was the famed night rider Lieutenant Colonel Paul Revere, who was in charge of artillery.

As overall commander, Saltonstall's orders were to eliminate the British presence in Penobscot Bay. He was urged to "preserve the greatest harmony with the commander of the land forces." Unfortunately, Maine did not provide its share of troops. "They were short in quality as well as short in numbers and at least one-fourth appear to be small boys and old men," wrote General Wadsworth.

The cranky Saltonstall's disposition was not improved when he learned that he was the second choice for the job. On paper, however, his amphibious task force looked impressive. It consisted of eighteen armed ships, mounting 344 guns, and twenty-four transport and store ships carrying approximately

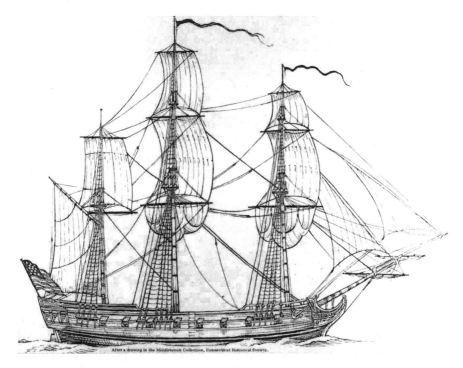

The ship *General Putnam* was an eighteen-gun privateer that was part of the American fleet. It was named for the Connecticut farmer who left his plow and walked to Massachusetts upon hearing the news of the Battles of Lexington and Concord. *Courtesy of Castine Historical Society, Castine, Maine.*

one thousand men. Logistical difficulties notwithstanding, the armada departed from Boston Harbor on July 19, amid high expectations.

From the British perspective, the American response appeared overwhelming. In his article "The Penobscot Fiasco," Russell Bourne wrote, "It hardly seemed possible that a British garrison of seven hundred men could withstand a siege by the greatest American armada of the Revolution." (Against this imposing fleet the British had but three fighting ships.) Even the British commander General McLean was skeptical, remarking that he had won nineteen battles but expected to lose the twentieth. Later, he called his adversaries "a pack of cowards or they would have taken me."

As the American fleet approached Castine, the batteries at Fort George opened fire. After a brief exchange, and to the dismay of his generals, the cautious Saltonstall withdrew his squadron before a significant number of troops could be landed. For the next two weeks, there were several bloody

skirmishes as the Americans made sporadic attempts to land their forces and assault Fort George. Meanwhile, Lovell and Saltonstall continued to argue over who was in charge. Lovell hesitated to commit his inexperienced troops to an attack on Fort George without Saltonstall's support from the sea.

Exasperated colonial army officers sent a delegation to Saltonstall, urging him to take more aggressive action with his fleet. Saltonstall, however, continued to feel that Castine Harbor was unsafe to enter. At one point, he responded to Colonel Brewer, "You seem too damned knowing about the matter! I am not going to risk my shipping in that damned hole!" And he did not. In fairness to Saltonstall, Fort George appeared stronger to those on the outside. Paul Revere wrote in his diary, "I had a fair view of the enemy fort through a good glass and could see that it was as high as a man's chin and built of squared logs."

After two indecisive weeks, Saltonstall finally responded to a direct order from his superiors in Boston and agreed to an attack. On August 13, as the American assault was being launched, a British relief fleet under Commodore Sir George Collier was spotted heading up Penobscot Bay toward Castine. Collier's flagship was the sixty-four-gun *Raisonable*, which was clearly superior to any of the American warships. Collier's fleet totaled seven ships, with an armament of 204 guns and 1,530 men. Although the American ships had a total of 344 guns, their sailors knew that they were no match for the better-trained British crews.

Ships in the bay. The appearance of seven British warships caused nineteen armed American vessels to retreat up the Penobscot River in a panic. The result was a naval disaster of epic proportions. *Courtesy of National Maritime Museum, Greenwich, England.*

Maine During the American Revolution

The battle was over before it had hardly begun. The next morning, a reluctant Saltonstall moved his fleet offshore to engage the British. After a couple of broadsides, the American ships, "showing perhaps as much prudence as cowardice," according to Russell Bourne, turned tail and headed up the Penobscot River. Appropriately, Saltonstall led the retreat in his flagship, the thirty-two-gun *Warren*. The unfortunate transports, hastily filled with colonial troops, fared less well. With the wind and tide against them, the ungainly ships were unable to ascend the river and were left behind by the swifter-sailing American warships. One by one, the twenty-four transports were either scuttled or run ashore and burned. The warships fled up the river with the British in hot pursuit. Most were destroyed when they reached Bangor to avoid falling into British hands.

Many historians consider the Penobscot Bay Expedition to be the worst naval disaster in American history until Pearl Harbor over a century and a half later. Lovell's army turned into a roving band of fugitives who fled back to their homes through the Maine wilderness. A month later, the starving survivors, including an enraged Paul Revere, began to straggle into Boston. It took three years, and a court-martial, before Revere was absolved of responsibility for the disaster.

Massachusetts had invested $8.5 million in the expedition, and the defeat was devastating to its war effort. Virtually the entire Massachusetts navy was wiped out in one day. In addition, 475 men were killed, wounded or captured. The crushing defeat for the Americans, however, was a cause for celebration among the British. The Tory Dr. John Calif, who became a physician for the British forces, wrote, "Thus did this little garrison with three sloops of war succeed in an enterprise of great importance against difficulties apparently insurmountable."

Back in Massachusetts, a board of inquiry was formed to investigate what went wrong. Saltonstall, defiant to the end, refused to testify. He was court-martialed anyway and discharged from the navy. The court-martial reported, "The joint command shared by Lovell and Saltonstall was sorely ineffective due chiefly to the obstinacy of Commodore Saltonstall and his unwillingness to use the decisively superior American fleet."

Historian George Buker, in his recent book, *The Penobscot Expedition: Commodore Saltonstall and the Massachusetts Conspiracy of 1779*, paints a different picture. His review of the expedition's records reveals that of all the officers involved, Saltonstall was the most aggressive and impatient for action. Buker suggests that there was a conspiracy by the Massachusetts Court of Inquiry toward the commodore from Connecticut who had been appointed by

Congress. Fourteen years later, Congress accepted the findings of the court-martial, however, and paid Massachusetts $1.2 million in compensation for Saltonstall's "uniform backwardness and want of proper spirit and energy."

At the end of his book, Buker relates an intriguing story to further support his point. A few months after his court-martial, Saltonstall contacted Adam Babcock, who owned the brig *Minerva*. Saltonstall had the temerity to request permission to convert *Minerva* into a cruiser (privateer) and assume command. Babcock's response was interesting. "It is perfectly agreeable to me that you should command the brig as a cruiser rather than as a merchantman, and chiefly that you may regain the character with the world which you have been most cruelly and unjustly robbed of. You never lost it with me." This was high praise from a man who had just lost a ship in the fiasco on the Penobscot River.

Minerva was converted into a sixteen-gun brigantine and enjoyed a successful cruise as a privateer. (A privateer was a private warship authorized by a country's government to attack foreign shipping during wartime.) Among its prizes was the British vessel *Hannah* carrying a cargo worth £80,000. Interestingly, one of the big investors in the enterprise was Paul Revere. The Penobscot Expedition was clearly a disaster, but can we blame its failure on Commodore Saltonstall?

THE COMMANDER: EDWARD PREBLE AND USS *CONSTITUTION*

John Paul Jones was the first American naval officer to gain public recognition for his dramatic triumphs against the British during the American Revolution. Edward Preble's leadership while in command of USS *Constitution* in the Mediterranean Sea gained international respect for the fledging United States Navy. Preble was also responsible for establishing many of the modern navy's rules and regulations.

Edward Preble was born in Falmouth (present-day Portland) in 1761. His father, General Jedidiah Preble, was a colonial military officer, merchant and politician. Both of Preble's parents (his mother was Mehetable Bangs Roberts) believed in the importance of education, and he was sent to the Dummer School (today the Governor's Academy) in Byfield, Massachusetts.

At the start of the American Revolution, Preble ran away from school to serve on a privateer. In 1779, at the age of eighteen, he joined the Massachusetts state marines as a midshipman and saw action on the twenty-

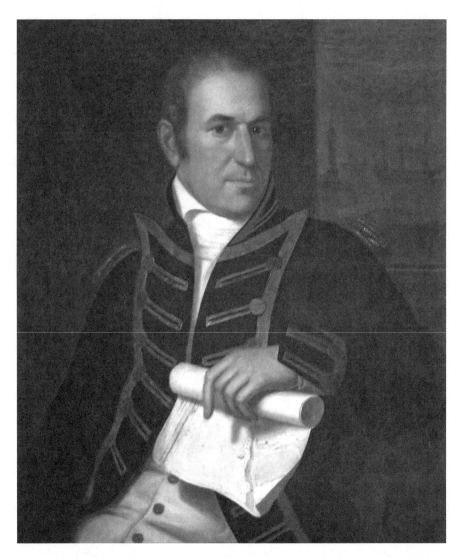

Edward Preble was a Portland native who is considered by many to be the father of the United States Navy. From 1803 to 1804, Preble commanded USS *Constitution* and was the leader of the American fleet in the First Barbary War. *Courtesy of Maine Memory Network.*

six-gun frigate *Protector*. The ship was captured in 1781, and Preble, like Jeremiah O'Brien, spent time on the infamous *Jersey* prison ship. Upon his release, he returned to duty as first lieutenant on the Massachusetts state sloop *Winthrop*.

Preble distinguished himself during the Revolution when he led a boarding party in a daring raid that captured the Loyalist privateer *Merriam*

in Castine, Maine. He and fourteen volunteers boldly sailed up to the ship and jumped onboard before the startled British were aware of what was happening. (The British apparently thought that the oncoming sloop was an American prize being sent into the harbor.) Most of the British crew leapt overboard, and Preble sailed the captured brig out of the harbor under a hail of fire.

After the Revolution, Preble spent the next fifteen years serving in what today would be considered the merchant marine. His tour ended in 1798 when he was appointed first lieutenant in the newly formed United States Navy. The navy was created to deal with what was to become an undeclared war with France. In 1799, Preble was given command of the fourteen-gun brig *Pickering*, which he took to the West Indies with orders to safeguard American shipping interests. The next year, Preble was promoted to captain and given command of the frigate *Essex*. In an effort to extend the United States presence around the world, he was ordered to sail *Essex* to the Pacific by way of the Cape of Good Hope. The mission was a rousing success when *Essex* guided a convoy of fourteen merchant ships safely back to New York.

The climax of Preble's career was when he was given command of the navy's Mediterranean squadron. In 1803, he transferred his flag to USS *Constitution*, one of six extra-large frigates that had recently been built to protect American interests around the world. USS *Constitution* was indeed a formidable ship. It carried forty-four guns, and its hull was made of seven-inch-thick live oak planks held together by copper spikes and bolts forged in Boston by Paul Revere.

Preble made a name for himself as leader of the Mediterranean squadron. When his ships reached Gibraltar, he discovered that a major conflict had broken out between the United States and the North African Barbary states of Morocco, Algiers, Tunis and Tripoli. As commander of the squadron, Preble was charged with bringing the war to a successful conclusion.

The Barbary pirates, as they were known, had long preyed on European traders, so it was no surprise when they began to demand tribute for "protection" from the American merchant vessels sailing in the Mediterranean. As early as 1786, Thomas Jefferson, then the American ambassador to France, had asked a Tripolian diplomat why his government was so hostile to American ships even though there had been no previous conflict. He received the following response: "It was written in their Koran, that all nations which had not acknowledged the Prophet were sinners, whom it was the right and duty of the faithful to plunder and enslave." Jefferson was told, however, that for a large sum of money American ships

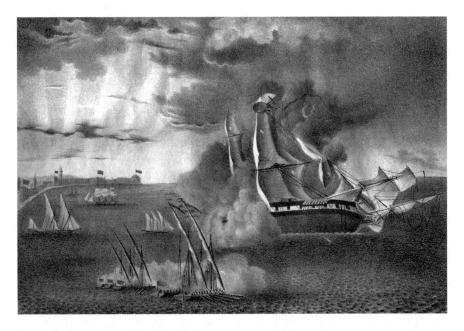

The American frigate USS *Philadelphia* on the rocks in Tripoli Harbor. Commander Preble planned a daring raid that destroyed *Philadelphia* so its captors could not use it. *Author's collection.*

would be left alone. For a time, the United States complied, but by the early nineteenth century the conditions had changed.

This was the situation that Preble faced when he took command of the squadron late in 1803. He proceeded to negotiate a truce with Morocco through a combination of force and diplomacy before moving on to Tripoli. Even before reaching the city he learned that USS *Philadelphia*, under the command of Captain William Bainbridge, had run aground off Tripoli. The ship had been captured and Bainbridge and his crew taken prisoner. *Philadelphia* sat helplessly in the harbor with the Tripolian flag on its mast, a "humiliating symbol of American powerlessness in the Mediterranean," wrote Ian Toll in his recent book, *Six Frigates*. Preble quickly realized that something had to be done to make sure *Philadelphia* could not be used by its captors. Indeed, the ship had already been renamed *Gift of Allah*.

Preble planned a daring raid, reminiscent of his Castine attack on *Merriam*, to be carried out by one of his top lieutenants, twenty-five-year-old Stephen Decatur. Using a recently captured Tripolian ketch as a Trojan horse to relax the guards on *Philadelphia*, Decatur entered the harbor with an all-volunteer crew on the night of February 16, 1804. His objective was to destroy the

captured ship so that it would be of no use to the Tripolitans. *Philadelphia* was successfully captured, the guards were driven off and the ship was burned at its moorings. The next morning, the light from the still-burning *Philadelphia* could be seen from forty miles away.

When news of the raid got back to the United States, Decatur instantly became a national hero. Horatio Nelson, the great English admiral, is said to have called it "the most bold and daring act of the Age." Decatur followed this with other heroics in the Barbary War and the War of 1812, which his recent biographer James De Kay notes "made him the stuff of legend." It should also be noted, however, that Decatur was just one of a number of junior officers serving under Preble who went on to distinguished naval careers. Some of the others included Isaac Hull, James Lawrence, David Porter and Charles Steward.

It should come as no surprise that after the burning of *Philadelphia*, Preble was unable to secure the release of Bainbridge and his crew. Indeed, they languished in prison until 1806. Meanwhile, the war against Tripoli dragged on. In the summer of 1804, Preble mounted several more sea offensives against the city. His forces were strengthened with the addition of gunboats and bomb ketches from the Kingdom of the Two Sicilies, whose leaders were equally interested in ridding the seas of the Barbary menace. Several Tripolian gunboats were sunk, though the strongly fortified city was able to resist capture primarily because of the lack of a supporting army.

In the fall of 1804, Commodore Samuel Barron (his brother James subsequently killed Decatur in a duel) relieved Preble, who returned to the United States bitterly disappointed over his failure to complete his mission. Much to his surprise, however, he found that he had become a popular hero because of his deeds in the Tripolian War. Congress gave him a medal commemorating his deeds as "the Vindicator of American Commerce." It is also important to note that Preble's actions while in the Mediterranean led to the United States' firm anti-negotiation stance, which a few years later led to the end of tribute payments.

Many of Preble's procedures have become official naval doctrine. For example, he insisted that his ships be kept in a state of readiness for action, which was a procedure not always followed by many officers at the time. Although he had a harsh temper and was a severe disciplinarian, Preble served as a role model for his subordinates through his vigor, his decisiveness and his refusal to give up even when confronted by overwhelming odds.

Perhaps most importantly, Preble inspired a whole generation of naval officers who became known as "Preble's Boys," some of whom have been

mentioned previously. As commodore of the Mediterranean squadron, he was keenly interested in the welfare of the common sailor. At the same time, he was constantly encouraging his officers to contribute their ideas and gave them credit when they were successful.

Edward Preble was to live two and a half more years. During this period, he served as a naval adviser to President Thomas Jefferson until poor health forced him to retire to his home in Portland, Maine. Preble spent his final months supervising a naval yard in Portland. He died on August 25, 1807, from a chronic "stomach disorder" at the age of forty-six.

Preble's name lives on in the twenty-first century. In 2002, the United States Navy commissioned a guided missile destroyer, the sixth warship to bear his name. There is a Preble Hall at the United States Naval Academy and a Preble County in Ohio. There is a Preble High School in Green Bay, Wisconsin, and not surprisingly, there is a Preble Street and a Fort Preble in Portland, Maine.

On April 19, 1799, Benjamin Stoddert, secretary of the navy, wrote a letter to President John Adams that personifies the career of Edward Preble:

> *Our Navy ought to be commanded by men who, not satisfied with escaping censure, will be unhappy if they do not receive and merit praise; by men who have talents and activity, as well as spirit, to assist a judicious arrangement of the force under their command or to cure the defects of a bad one.*

Part III

ANTEBELLUM MAINE

THE SETTLER: ABRAHAM SOMES MOVES TO MOUNT DESERT ISLAND

In 1816, eighty-four-year-old Abraham Somes was served with a writ of ejection from lands he had lived on for the previous fifty-four years. Lacking a deed, Somes was afraid that he would lose rights to the property on Mount Desert that had been verbally granted to him by Francis Bernard, governor of Massachusetts, in 1762. A letter Somes wrote to his Boston lawyer, Eben Parsons, explains his situation:

> *Sometime before the French* [and Indian] *War was over I received a letter from Sir Francis Bernard asking me if I wanted to farm on the island of Mt. Desert. I excepted* [sic] *the proposal and accordingly came down immediately after the War was over and peace ratified so that I could be safe in moving into the wilderness. I came to this place in 1761 and made a pitch on this lot where I now live. In June the year following I moved my family and have occupied the same ever since without any interruption from any claimant until of late.*

Somes was no stranger to the Maine coast. He had visited Mount Desert as early as 1755 to fish. In 1759, he was on the island to cut hay on the salt marshes. He moored his boat at the entrance of what is today Somes Sound and saw groves of oak trees growing in abundance. Somes was a cooper by trade, and he quickly realized the value of oak timber for casks and

Thaddeus Somes and his wife, Emilie Somes, in front of their house in Somesville, circa 1905. Thaddeus was the great-grandson of Abraham Somes, who moved to Mount Desert in 1762. *Courtesy of Mount Desert Island Historical Society.*

barrels. Nellie Thornton wrote in *Traditions and Records of Southwest Harbor and Somesville*, "Little did Abraham Somes realize as he walked through the oak forest that calm Sunday morning, that many generations of his descendants would occupy the land for years to come." In spite of having nothing in writing from Governor Bernard except a pledge written on a piece of birch bark, Somes won his case due to his long residence on the land.

At the end of the French and Indian War in 1762, the General Court of Massachusetts awarded a grant of half of Mount Desert Island to the newly appointed governor Francis Bernard in "consideration of his extraordinary services in the recent war." (Bernard was a clever lawyer who had prepared a brief giving Massachusetts title to much of coastal Maine.) Bernard was anxious to keep the province of Maine under the control of Massachusetts, and he was also interested in promoting settlement of the area as a personal business venture.

Governor Bernard had evidently heard of Somes's interest in Mount Desert, hence his invitation to settle in the area. With a large extended family in Gloucester, Abraham was clearly anxious to strike out on his own. Bernard offered Somes free land, figuring that he would help attract new settlers. Accordingly, Somes, his wife, Hannah, and their four young daughters sailed from Gloucester and moved into the log cabin that Somes

had built the previous fall. In due course, nine more children were added to the Somes family.

In the fall of 1762, Governor Bernard decided to inspect his new possessions, and in late September he cruised Down East in his sloop, *Massachusetts*. On October 7, Bernard sailed "up The River [as Somes Sound was then called]. We went on shore and into Somes' log house, found it neat and convenient, though not quite furnished, and in it a notable woman and four pretty girls, neat and orderly. Near it was many fish drying." When Bernard met Somes, he advised him to "build mills and clear my farm, for you shall never be interrupted."

Upon his return to Boston, Bernard began a campaign to encourage settlement, although, as George Street reminds us in his history of the island, "it is evident that his [Bernard's] proprietary rights were not infrequently in conflict with squatter rights established by the settlers."

"The Somes family did not remain long in solitude," wrote Ohio State history professor Virginia Somes Sanderson in 1982. James Richardson arrived in 1763, and within a year settlers began to flock to Mount Desert. (Eastern Maine was America's first frontier. Somes and Richardson settled before Daniel Boone crossed the Appalachians.) Richardson was described as "an enterprising, industrious man with a considerable education for the times." He built a mill at the head of Somes Sound and started a lumber business; he raised a family of eleven children. For many years, Somes and Richardson were prominent in the affairs of the town of Somesville, which at the time was referred to as "Between the Hills."

In 1960, Samuel Eliot Morison asked the question, "Who was the first European to see Mount Desert Island?" In 1525, long before Abraham Somes appeared, Morison tells us that Estevan Gomes, a Portuguese in the service of Spain, voyaged along the Maine coast with orders to find a strait leading to the Pacific. "When he hit the Penobscot River, he thought he had it"; that is, until he reached the falls at present-day Bangor.

We know that in 1604, Champlain, on the first of his three explorations of the New England coast, sailed up the eastern side of Mount Desert to make sure that it was indeed an island. Champlain's description is well known: "This island is very high and cleft into seven or eight mountains all in a line. The summits of most of them are bare of trees, nothing but rock. I named it I'sle des Monts-deserts [Isle of Bare Mountains]."

For the next century and a half, eastern Maine was the scene of frequent bloody conflicts between England and France. Mount Desert especially became a virtual no-man's land. Not until 1759, when the British general

Wolfe defeated the French outside the city of Quebec, was Maine finally deemed safe for habitation. At that point, settlers like Abraham Somes and James Richardson began to bring their families into the strife-torn region.

Governor Bernard deserved a better fate. Following his visit to the Somes cabin, he returned to Boston and began to plan further settlements on the island. As sole proprietor, and with a wife and ten children to support, he saw a chance to make himself a rich man. Unfortunately for Bernard, his timing was poor. The mood in Boston turned ugly after the Stamp Act riots in 1768, and as a champion of British authority in Massachusetts, Bernard was a marked man. He was recalled to England in 1769, and his property was confiscated during the Revolution.

The Plantation of Mount Desert was incorporated into a township in 1789, along with the nearby Cranberry Islands. Author George Street tells us that "Between the Hills" (Somesville) was "the most important business place on the island." Members of the extended Somes family owned a sawmill and a gristmill, kept a store, ran a tanning yard and two shipyards, operated the blacksmithing and shoemaking shops and ran the single post office on the island.

The people of Mount Desert were ardent Patriots during the Revolution and the War of 1812, though they paid a price for their lack of loyalty. During both wars, British ships roamed freely up and down the coast, and the local population was obliged to pay tribute to the British or see their property destroyed. Settlers on Mount Desert were particularly vulnerable because of their remote location, and they suffered from frequent British attacks. There were a few victories, however, like the Battle of Norwood's Cove in 1814, when local militia on Southwest Harbor drove off a landing party from the British sloop *Tenedos*.

Here's a health to King George, God damn him;
May the crows pick his eyes, and hang him,
And drive him all round the ramparts of hell,
God damn him!

—*Nat Dyer*

For the first half of the nineteenth century, the population of Mount Desert grew steadily. The economy was based on timber and the sea, though by mid-century most of the first growth of trees had been cut off. Bass Harbor, Southwest Harbor and Cranberry Harbor became prosperous fishing ports, and Samuel Eliot Morison reminds us, "Schooners and brigs were built in every cove and harbor by local men."

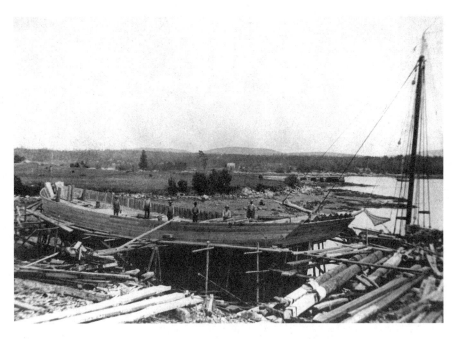

Shipbuilding on Mount Desert. Maritime historian Samuel Eliot Morison reminds us that "schooners and brigs were built in every cove and harbor by local men." *Courtesy of Mount Desert Island Historical Society.*

In 1844, Thomas Cole, the British-born artist and founder of the Hudson River School of landscape painting, came to Mount Desert. Cole's work was renowned for its realistic and detailed portrayal of the American landscape, and Mount Desert offered Cole new challenges. He made sketches of the island, which he took back to New York and turned into paintings. In time, Cole's work inspired a generation of young artists, including the gifted Frederick Church.

Starting with his first visit in 1855, Church produced a series of dramatic landscapes and seascapes of Mount Desert that critics and the art public raved about. The result was that by the late 1850s the island had become a popular destination for artists and writers, as well as wealthy businessmen and their families. Hotels began to appear, though getting to the island was a complex process that began with a train ride to Portland, followed by a steamer to Castine and finally a schooner to the island itself.

After the Civil War, tourists began to visit Mount Desert in greater numbers, and by 1890, Bar Harbor rivaled Newport, Rhode Island, as *the* elegant place to spend the summer. One of the controversies of the early

Main Street, Somesville, early twentieth century. Local residents feared "the multiplication of city sights and sounds." *Courtesy of Mount Desert Island Historical Society.*

twentieth century was the question of automobiles. "We must keep the devil wagons off the roads," thundered Dr. Robert Grindle of Somesville at a highly charged meeting held in Northeast Harbor in 1913.

Acadia National Park was established in 1916, and it has since become one of the jewels of our national park system. In 1926, island historian George Street warned:

> *The future of Mount Desert as a summer resort is largely dependent upon the judgment and taste of the permanent residents. The charm of the place can easily be impaired. The multiplication of the city sights and sounds that summer people come to Mount Desert to escape, are all to be avoided.*

THE GOVERNOR: WILLIAM KING AND THE FIGHT FOR STATEHOOD

Students of American history will tell you that in 1820 Maine became the twenty-third state admitted to the Union. Admission was part of the

Missouri Compromise, a deal worked out in Congress whereby Maine would be admitted only if Missouri were admitted at the same time. What took so long? After all, Maine had been around as a province of Massachusetts since the seventeenth century. And what was William King's role in it all?

Coastal Maine took quite a beating during the American Revolution. What made matters worse was that the province received little support, or sympathy, from its government in Massachusetts. Maine had supported the Revolution; there were over one thousand Mainers at Valley Forge. Maine author Louise Dickenson Rich wrote, "If the colonists of the Maine coast had given up and thrown in their lot with the British it would have been neither surprising or blameworthy."

Not surprisingly, agitation for statehood—or separation, as it was called—began shortly after the Revolution. Native Americans became wards of the state, a condition that opened their lands to development. With the threat of Native American uprisings significantly reduced, immigration increased rapidly. By 1790, the population of Maine had reached 96,000, double what it had been at the end of the war. By 1810, the number had reached 230,000, a very rapid expansion.

The population of Maine was divided over the issue of statehood. Merchants and shipowners who lived in the towns along the southern coast of the province were comfortable doing business with Boston and tended to be opposed to the idea. To many of the newly arrived settlers, however, the idea of separation was appealing. Their rural way of life was very different from that of Massachusetts, their remote and rapidly industrializing big brother to the south.

Maine was also beginning to develop a separate identity. In 1785, the *Falmouth Gazette* was established with the specific purpose of promoting separation from Massachusetts. It was the first newspaper to be published in Maine. In 1791, the Portland Head Lighthouse was built. Today, it is the oldest lighthouse in the United States. Three years later, Bowdoin College received a charter from the General Court of Massachusetts and became Maine's first postsecondary institution. The Bank of Portland was established in 1799, and in 1801, the first public library was founded in Castine. A cotton mill in Brunswick and a paper mill in Bangor were further signs that Maine was beginning to prosper.

Twenty-seven-year-old William King first appeared on the political scene in 1795 as the representative for Topsham in the Massachusetts House of Representatives. King moved to Bath, where he soon became known as "the Sultan of Bath" because of his many successful business activities.

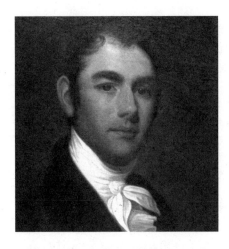

This portrait of William King, Maine's first governor, was painted by Philip Spooner Harris. It shows King as a young Bath businessman in 1806. *Courtesy of Maine Memory Network.*

In addition to his extensive real estate holdings, King opened the previously mentioned cotton mill in nearby Brunswick, founded the first bank in Bath and became one of the leading shipowners in the province.

King did not have an easy childhood. One of six children, he was born in 1768 in Scarborough, Maine. His formal education was limited due to the sudden death of his father when he was seven. Shortly after this, King went to work in a sawmill, where he worked for the next decade. The man destined to be Maine's first governor was an enterprising fellow. In the tradition of a Horatio Alger novel, he quit his job and moved to Topsham, where, six years later, he opened his own sawmill. When he moved on to Bath, King's career began to take off.

King went into farming and raised large crops of apples and potatoes, which his growing fleet of ships carried to the West Indies and Europe. He represented Bath in the General Court of Massachusetts and became a colonel in the local militia. He also married Ann Frazier, "the belle of the season in Boston society," and brought her back to an impressive house he had built for them in Bath. The poor boy from Scarborough had come a long way.

King joined the Democratic-Republican (Jeffersonian) Party and, in 1807, was elected to the Massachusetts State Senate. From this position of leadership, he courted the political support of settlers who were now thronging to Maine. His message of independence from the economic and political restrictions of the Federalist-dominated government in Boston resonated with the egalitarian ideas of new arrivals. By 1811, the dynamic King had become the dominant figure of both his party and the separation movement in Maine.

The War of 1812 was an important step in the drive for statehood. At the start of the war, Massachusetts appointed King to the rank of major general in the Maine militia. (He was known as "the General" for the rest of his life.) King spent much of his time preparing coastal defenses and recruiting for

Stone House Farm, Bath; built in 1812 by William King. This unusual stone farmhouse is the earliest known example of Gothic Revival architecture in the state. *Courtesy of Oscar Marsh Postcard Images, Sagadahoc History and Genealogy Room, Patten Free Library, Bath, Maine.*

the army but received little help from Boston. By the middle of the war, it had become clear to King and others that the Federalist-led government in Massachusetts was quite ready to sacrifice the interests of Maine. This was painfully apparent when the British occupied the coast from Penobscot Bay to Passamaquoddy Bay. According to Louise Dickinson Rich:

> *The failure of Massachusetts to provide adequate protection for the Maine coast during "Mr. Madison's War" and the strong local feeling that Maine was being treated like a poor stepchild by her supposed government, resulted in secession from the commonwealth.*

Secession, or separation, did not occur immediately. In 1816, the Massachusetts General Court agreed that Maine could hold a referendum, but the results were inconclusive. Three years later, King and his fellow Jeffersonians revived the issue again, and in the vote that followed, 17,091 supported the issue, whereas 7,132 voted against it. As University of New Hampshire history professor Charles Clark wrote, "The voters had now spoken overwhelmingly for statehood. The next job was to frame a constitution." In 1819, King was chosen president of Maine's Constitutional Convention, and he was a leader in the discussions that followed.

Maine's constitution was considerably more democratic than that of its former proprietor to the south. It provided for absolute freedom of religion and universal manhood suffrage, which was similar to that of Massachusetts. It went beyond Massachusetts in that it omitted the property and religious tests that the Massachusetts Constitution imposed. Maine also added a tax on unimproved lands held by speculators—a direct attack on the business community. Maine was also the first state to give not only voting rights but also schooling to all males regardless of race. Historian Ronald Banks wrote, "All in all, the Maine Constitution emerges, along with the constitutions of several Western states, as one of the more democratic constitutions of the time." To no one's surprise, voters overwhelmingly approved the constitution when it was submitted to a referendum.

When Maine's bill for admission to the Union was brought before Congress in December 1819, it faced the unexpected problem of slavery. According to Professor Clark, "It was Maine's bad luck that her application for statehood coincided exactly with a turning point in national politics." Missouri had already applied for statehood, and in the tortuous congressional negotiations that followed, the question of whether slavery should be permitted in future states became a hot topic. The battle raged for months until Senator Henry Clay from Kentucky proposed his famous compromise. Simply stated, the Missouri Compromise said that Missouri would join the Union as a slave state and Maine as a free state.

Appropriately, Maine's first governor was William King, who had championed the drive to statehood. He won all but 31 of the 22,014 votes cast. On June 2, 1820, King addressed the new legislature assembled in Portland for the first time. The first paragraph of his "State of the State" address is worth noting:

Gentlemen of the Senate and of the House of Representation.

The political connection, which had so long subsisted between Massachusetts and Maine being dissolved, it is a source of much satisfaction to reflect, that the measures, adopted for its accomplishment, have effected the object in the most friendly manner. A great and powerful Commonwealth voluntarily yielding up her jurisdiction over a large portion of her citizens and territory, over whom she held an undisputed and rightful sovereignty—These citizens peaceably and quietly forming themselves into a new and independent State, framing and adopting with unexampled harmony and unanimity a constitution embracing all the essential principles of liberty and good

government. These are events, which constitute a memorable era in the history of our state—events for which you no doubt, as well, as our fellow citizens in general, will acknowledge with gratitude that divine goodness, which directs and controls the concerns of men.

The Portland paper *Eastern Argus*, in its June 9 edition, reported on King's speech: "We are pleased; and we believe that the public is generally pleased, that our chief magistrate has chosen this mode of communicating with the legislature." The editor reinforced King's call for a revision of the laws and the improvement of manufacturing enterprises by exempting them from taxes. The paper concluded by saying, "We pledge the whole of the little credit we have with the public" in supporting it.

King was an active governor for the year he was in office. To encourage industrial growth, he advocated tax rebates for manufacturers who built factories. He also tackled the diplomatically delicate question of Maine's boundary with New Brunswick, which had lingered since the end of the Revolution. The boundary line was not finalized for another twenty-two years, but King realized the importance of addressing the issue.

After a year in office, King resigned as governor when President James Monroe named him to a commission to implement the 1819 Adams-Onis Treaty. The treaty gave Florida to the United States and established a boundary between the United States and Spanish Mexico. The United States did not pay Spain for Florida, but it did agree to assume the claims of American citizens against Spain up to a maximum of $5 million.

The commission met from 1821 to 1824 and handled the hundreds of claims by Americans against Spain. It was composed of a number of prominent Americans, including King, William Wirt and Daniel Webster. A further benefit of the treaty was that it kept the United States from becoming embroiled in issues surrounding the Mexican struggle for independence.

King returned to Maine and resumed his business career, although his fortunes declined as he grew older. During the remainder of his life, he also served as a trustee of Bowdoin College and Waterville College, now Colby College. He was appointed commissioner of public buildings in Maine, and when the capital of the state moved from Portland to Augusta, he oversaw the building of the statehouse, which opened in 1832. In 1835, King ran for governor as a member of the Whig Party, but he lost. William King died at his home in Bath on July 17, 1852, at the age of eighty-five.

THE CANAL BUILDERS: CHARLES BARRETT, HENRY KNOX AND THE GEORGES RIVER CANAL

*Ten miles east of Pemaqid is found the Georges River. The tide goes fifteen
miles up that river and meets a fall, which while checking its progress offers
lumber in great plenty. There are large ponds at the Head of the Tide,
which it is said, may be rendered navigable a great way into the country.*
—History of the District of Maine,
James Sullivan, 1744–1808

Charles Barrett was an enterprising Yankee from New Hampshire who
arrived in the Georges River region of Maine (also known locally as the
St. Georges River) at the end of the American Revolution. Barrett had
received a grant of land from Massachusetts for 120 lots near present-day
Hope, Maine. In return, he agreed to construct a road to Camden, build a
meetinghouse and schoolhouse and provide a minister and lots for forty-five
families—all at his own expense. Barrett was granted 80 lots for himself,
which he could sell off.

The settlement of a virtual wilderness was a formidable challenge for any
man, but Barrett was a very determined fellow. It took him only a short
time to realize that getting settlers to the area would be a lot easier by water
than by land. Between 1785 and 1790, many used the Georges River for
transport to their new homes in the Warren-Union area.

Barrett built a sawmill and persuaded the requisite forty-five families to
move to the area. He then began the process of improving the water transport
system. In November 1792, Barrett received a charter from the Massachusetts
General Court, which identified lands "beginning twenty-five miles above the
Head of the Tide on the George's River…to communicate with the sea at
the mouth of the said river through locks and canals." Lacking a competent
engineer, it took Barrett three costly and frustrating years to realize that he
would be unable to complete his plans to build a system of locks and canals
that would link the upland waters of the Georges River to the sea.

Until railroads appeared in the middle of the nineteenth century, the
preferred method of travel in the United States was by water. Roads,
especially in Maine, were primitive, and as the Charles Barrett example
illustrates, water transport was faster, simpler and cheaper. Because of rivers
like the Georges, the forests of the interior could be opened for development.
Trade would improve the local economy, which in turn would benefit the
region and the nation.

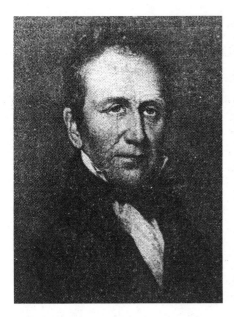

Charles Barrett was an enterprising Yankee from New Hampshire. In the early 1790s, he attempted to build a canal on the Georges River. *Courtesy of Warren Historical Society, Warren, Maine.*

Even before he became president, George Washington made it clear to those around him how important canals were for the development of the fledgling nation. After surveying lands in his native Virginia, Washington felt that canals were valuable as a way to "bind western settlements geographically and politically to the seaboard states," according to Hayden Anderson in *Canals and Inland Waterways in Maine.*

Anderson goes on to say, "Even as roads proliferated, waterways remained for settlers the usual means of travel and trade." People traveled up rivers by boat, portaging around falls and rapids. By 1793, thirty canal companies were incorporated in the original thirteen colonies, including three in Maine, which was still part of Massachusetts.

General Henry Knox was Washington's close friend and confidant for twenty years, and he must have heard canal talk from his boss on many occasions. Thus, when Knox resigned as secretary of war and moved his family to Thomaston in 1795, he was ready to pounce when he saw that Charles Barrett's canal scheme was failing. His offer of "one hundred pounds and five dollars" was accepted.

Knox was able to move to Maine because his wife had inherited the vast Waldo Patent from her father. General Knox, who was a huge man with almost limitless energy, built a mansion for himself in Thomaston and became a virtual feudal lord. He opened a store, built a wharf and sold land to settlers. He was involved in farming, granite cutting, lumbering, lime burning, salt making and shipbuilding. However, the key to his business success was the construction of locks and a canal on the Georges River.

Canals fascinated Knox. In a letter to a friend, he referred to them as "among my favorite hobby horses." Knox hired a French engineer named Varlé with canal-building experience in Europe. Varlé's recommendations—to

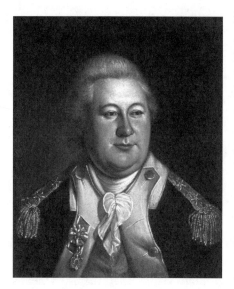

In 1794, former secretary of war Henry Knox purchased the Georges canal from Barrett and set about improving and extending the canal system. *Courtesy of Independence National Historical Park, Philadelphia, Pennsylvania.*

use brass, iron, cement and stone as building materials—were ignored, probably because Knox felt they were too expensive.

In 2006, Amanda Rudy wrote an informative paper for the Henry Knox Museum in Thomaston called "Henry Knox and his Hobby Horse: The Georges River Lock and Canal System." Midway through the article, Rudy chronicles the lengthy correspondence between Knox and Varlé regarding canal construction and materials. Knox appeared not to trust the Frenchman's advice. Varlé, in turn, felt that he needed more men to do the job, and he begged the General to consult "other men of learning" who would support his views on construction materials.

Varlé eventually backed down and agreed to build a canal that would last forever and be inexpensive to maintain. Given his previous concerns, this was a ridiculous statement to make. A possible reason for the Frenchman's acquiescence might have been his interest in Knox's nineteen-year-old daughter, Lucy. Knox was not pleased when he found out and wrote to Varlé:

> *Sir,*
> *My daughter has showed me the letter, which you wrote her. This conduct renders it improper for [?] you [?] into my house and you will therefore please to govern yourself accordingly.*
> *Your Humble Servant,*
> *HKnox*

Henry Knox was an impatient man, and Varlé was dismissed a few months later, ostensibly for not completing the job on time. Varlé had the last laugh, however. There was a major drought while the canal and locks were under construction, and Varlé was long gone before there was enough water in the river to test the locks. Building the sides of the canal out of

sod, instead of stone and timber, turned out to be a disaster. When the river was finally high enough to run a test, the sod had withered and dried out. Months of labor were swept away in an hour, and a furious Henry Knox had no one to blame but himself.

The next year, Knox hired Life Wilson, a carpenter from Massachusetts, to rebuild the locks with stout timbers, and for a decade boats made the run to Union. In addition to timber, Knox shipped furniture, harness equipment, apples, limerock and lime in casks. The General never made much of a profit from the canal, since much of the freight that was shipped was lumber from his mills. The canal was well managed, however, and a great improvement over the slow, roundabout land route.

In 1806, Henry Knox died at the age of fifty-six from an infection from a bone that stuck in his throat. His untimely death caused all of his business activities to decline, including the canal. In need of major repair, it was abandoned within a year. Amanda Rudy concluded her paper by summarizing Knox's contributions:

> *The canal along with the mills not only provided the ability of inland farmers to trade, but also provided work for many men with construction. In addition, by having a transportation route inland, it greatly enabled the General to do more with his own lumber trade and shipbuilding businesses, which in turn benefited the local workforce and economy.*

New England was hit by hard times over the next few years. The Embargo Act in 1807 caused coastal commerce to come to a virtual standstill, and the War of 1812 further discouraged investment. Following the success of the Erie Canal in 1825, a group of investors from the Georges Valley region revived interest in reopening the canal in the 1830s. Unfortunately, the Panic of 1837 postponed canal talk for a few more years.

Hayden Anderson tells us, "Some valley men continued to cherish the hope of improving the Georges River." In 1845, during a period of economic prosperity, a number of investors joined in another effort to improve the river. In 1846, the state legislature authorized the Georges Canal Company to begin construction of a canal from Warren to Stevens Pond in Liberty, Maine, a distance of thirty-four miles.

On Christmas Day 1847, the first canalboat, appropriately named *General Knox*, "came down from Appleton, passing through the Warren locks on its way to Thomaston, where they had great rejoicing," wrote a local resident. "They rang bells and the East Thomaston [now Rockland] folks came over

and thought they were having a great fire." July 4, 1848, was celebrated by Captain George Coombs running his twenty-three-ton steamer, *Gold Hunter*, up the canal to Sennebec Pond.

Unfortunately, the new canal was no more successful than its predecessors. With the volume of traffic declining and maintenance costs mounting, the last boat was poled down the canal in 1850. In 1859, Cyrus Eaton, in his *History of Thomaston*, wrote, "A great freshet took away a piece of both dams together with the Union bridge and the Warren toll-bridge."

Although not a financial success, the sixty-year effort to improve transportation on the Georges River undoubtedly stimulated the growth of population, industry and trade in the valley. Today, the Georges River Canal is on the National Register of Historic Places.

THE ACTIVISTS: AFRICAN AMERICANS ROBERT BENJAMIN LEWIS, REUBEN RUBY AND JOHN BROWN RUSSWURM

There were a number of African Americans who achieved prominence in Maine before the Civil War. Robert Benjamin Lewis, Reuben Ruby and Robert Brown Russwurm are three very different men whose accomplishments were particularly noteworthy.

Robert Benjamin Lewis

Robert Benjamin "Bob" Lewis was born in Gardiner, Maine, in 1798. Lewis's physical appearance was striking. He was tall, with long black hair, and of mixed African and Native American descent. As a young man, Bob had a reputation as a jack-of-all-trades who could fix almost anything. He painted houses, caned chairs and worked as a deckhand and farmhand.

As he grew older, Lewis's interests expanded. He aspired to be a missionary and preach the gospel in Africa. Bob Lewis never made it to Africa, nor is it known whether he was ever actually ordained as a minister. His studies did, however, give him grounding in the Bible and classical history, which he was to draw on later.

The former fix-it man showed a knack for invention and held at least three patents—a noteworthy achievement for anyone, especially an African

American in the 1830s. As a young man, he perfected a product that he guaranteed would make hair grow. Lewis called it his "inimitable hair oil" and demonstrated its potency to rapt crowds by showing off his long black locks, which reached over his collar. Apparently, he made a comfortable living from the sales of this product for many years.

Lewis also developed a machine he called the "Robert Benjamin Lewis Oakum and Hair Mill." The device, a variation on the cotton gin (teeth mounted on a cylinder, turned by a crank), was designed to separate the strands of old rope to produce oakum, used for caulking the seams of wooden ships. Lewis received a patent for the machine in 1836, and it was used in Maine shipyards for many years.

Historian Reginald Pitts, as quoted in *Maine's Visible Black History*, describes Lewis as a man who "challenged the assumptions of his time and place." In 1836, Lewis published *Light and Truth*, a book about black history and ethnology. Professor John Ernest of the University of New Hampshire described Lewis's work as "a study of the theological grounds of black nationalism and an early example of black liberation theology." According to the *Hallowell Gazette*, what Lewis was saying was that "men were originally created black and that the white man was of inferior stock." Lewis maintained that Plato and Julius Caesar were from Ethiopia and that Moses and Solomon were men of color.

In 1835, Lewis married eighteen-year-old Mary Heuston, the daughter of an escaped slave. In 1848, he moved his wife and ten children to Bath, where he built a house that still stands. Pitts tells us, "Lewis, secure in his belief that certain figures in classical history were Black Africans, named his children after historical figures of the period"; a son was named Euclid and a daughter, Artemisia.

Neighbors remembered Bob Lewis as a good citizen and an honest man. According to the *Hallowell Gazette*, he was "great on ancient history but manifested a peculiar sense of the classical." Despite the fact that he was well liked by his neighbors, Lewis wanted to leave the United States to escape the oppression of white America.

Lewis continued to do research for *Light and Truth* the rest of his life: "I have in contemplation the publishing of another work which will contain much more interesting matter." Expanded versions went through two more editions. The book is considered to be the most widely circulated publication on ethnology in the nineteenth century written by a black man.

Reuben Ruby

Reuben Ruby was born in 1798, the same year as Bob Lewis. Like Lewis, Ruby was an entrepreneur, although their similarities ended there. Ruby was known throughout New England as a vigorous opponent of slavery, as well as an active conductor on the Underground Railroad. In 1828, he founded the Abyssinian Religious Society in Portland and helped fund its meetinghouse.

In 1823, Ruby moved to Portland from nearby Gray. He first worked as a waiter and then bought his own hack, or coach, business. Ruby owned two hacks. His advertisement tells us that "he will be happy to attend to any calls which are made upon him. Every attention will be paid to accommodate those who wish to be conveyed to different parts of the City or elsewhere."

Ruby's big break came in 1832 when William Lloyd Garrison, the prominent abolitionist, journalist and social reformer, visited Portland. Hearing of his visit, the enterprising Ruby took the abolitionist on a sightseeing tour of the city in his coach. He invited Garrison to his home that evening and introduced him to the leading African Americans in the area. Thus began a lifelong association between the two men.

The next year, Ruby moved his family to New York City, where he became active in the antislavery movement at the national level. He got to know Arthur and Lewis Tappan, the wealthy Tammany Hall leaders who served as the "money men" for the abolitionist movement. When John Russwurm and Samuel Cornish founded *Freedom's Journal*, the first newspaper owned and operated by African Americans in the country, Reuben acted as an agent for the paper.

At the age of fifty, Ruby joined the California gold rush. Unlike many who headed west, he returned a rich man. According to the *Portland Argus*, after mining for four months he came back with $3,000. Ruby had previously purchased the land for the Abyssinian Society to build its church, and he was now able to loan the society money to complete construction of the building.

The Abyssinian Church, which grew out of the Abyssinian Religious Society, became the spiritual anchor for the three to four hundred African Americans living in the Portland area. It sponsored antislavery rallies and aided fugitives on the Underground Railroad. Perhaps most importantly, the church housed a school for black children.

For the remainder of his life, Ruby served as custodian of the Portland Customs House. He also spent a lot of time in court trying to recover the money he had loaned to the Abyssinian Society but which the society

Hack Stand—at Elm Tavern.

REUBEN RUBY,

Informs the public that he has two good Coaches, one or the other of which may generally be found at his old Stand, at the Elm Tavern, where he will be happy to attend to any calls which are made upon him. Every attention will be paid to accommodate those who wish to be conveyed to different parts of the City, or elsewhere. His residence is the second house on the east side of Preble Street, from the head, where he may be found at any time in the night.

This poster of Reuben Ruby's advertisement for his hack service was found in the 1834 Portland Directory. *Courtesy of Maine Memory Network.*

claimed was a gift. Eventually, Ruby was expelled from the church and never recovered his money.

Reuben Ruby died in 1878 and was survived by three sons, each of whom achieved a degree of prominence. William Ruby became the deputy fire chief of Portland. During a citywide fire, he was credited with saving the Abyssinian Church by wetting down the roof. George Ruby moved to Texas, where he became a state senator, and Horatio Ruby was involved with the Greenback Party in Maine. In 1880, he gave the seconding speech for governor-to-be General Harris Plaisted.

Most of what we know today about Reuben Ruby and his family is due to the efforts of Portland native Bob Green. Reuben's sister was Green's grandmother, four generations removed.

John Brown Russwurm

John Russwurm was an eminent antebellum African American. He was the first African American to graduate from Bowdoin College, and at the age of twenty-eight, he was editor of *Freedom's Journal*. In 1829, he immigrated to Liberia, where he worked as colonial secretary, a school superintendent and a newspaper editor. From 1836 until his death in 1851, Russwurm was governor of the Maryland Colony at Cape Palmas, on the West African coast.

Russwurm was born in Jamaica in 1799 to a white father and a black woman who was probably his slave mistress. John's mother died when he was eight, and he was sent to school first in Canada and then at Hebron Academy in Maine, where he graduated in 1819. Russwurm taught school for a few years in Boston before returning to Maine. He was offered financial assistance to attend Bowdoin College, and in 1824, at the age of twenty-five, he was accepted as a junior. At the time, the student body of Bowdoin numbered 136 male students between the ages of thirteen and twenty-one. Leigh Donaldson writes in *Maine's Visible Black History*, "He was separated from his fellow students not only by age, but by race."

Classmates remembered John Russwurm as a "young man of sound intelligence, and a great reader with a special fondness for history and politics." Not surprisingly, he was invited to join the Athenean Society by its president, Nathaniel Hawthorne. Russwurm graduated from Bowdoin in 1826, and he was the commencement speaker. His talk on the Haitian Revolution was widely praised in the Portland and Boston papers.

The next year, Russwurm moved to New York City, where he helped found *Freedom's Journal* with Samuel Eli Cornish, a Presbyterian minister. Although the paper lasted only two years, it was the first weekly in the country to be published by African Americans. *Freedom's Journal* covered a broad range of national and international topics, and its editorial page strongly condemned social injustices, including slavery and lynching. The paper was published in eleven states, the Caribbean, Canada and Europe.

Cornish soon left the paper, and Russwurm became senior editor. He used his position to advocate the colonization of Africa by African Americans, a view he had recently come to support. The immigration of free blacks

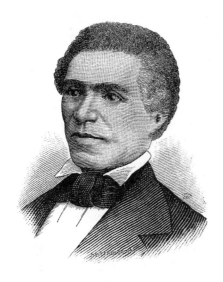

John Brown Russwurm was a graduate of Bowdoin College and editor of the abolitionist newspaper *Freedom's Journal*. In 1829, he immigrated to Liberia, where he took an active role in the affairs of the country. *Courtesy of John Brown Russwurm Collection, George J. Mitchell Department of Special Collections and Archives, Bowdoin College Library, Brunswick, Maine.*

to Africa was a controversial issue at the time, and Russwurm was increasingly pessimistic about the lack of opportunities for African Americans in the United States. Anticipating Marcus Garvey's back-to-Africa movement by three-quarters of a century, Russwurm called on blacks to abandon America and find new opportunities in Africa.

Russwurm resigned from *Freedom's Journal* in March 1829 and departed for Liberia. Leigh Donaldson tells us that in Liberia he helped establish a customs tariff, encouraged agriculture and trade and established a court system. When Russwurm became governor of the Maryland colony, he taught scientific farming, abolished slavery, established a currency and instituted education for both boys and girls.

In 1833, John Russwurm married Sarah McGill, daughter of the lieutenant governor of Monrovia, with whom he had four children. He remained in Africa for the rest of his life, with the exception of a brief visit to Maine shortly before his death in 1851.

I am indebted to H.H. Price and Gerald E. Talbot for their encyclopedic volume Maine's Visible Black History, *published in 2006 by Tilbury House.*

THE LUMBER BARON: SAMUEL VEAZIE

He had a huge, blocky head, clean jaw and his clamped lips testified to the drive within, while his eyes, the right narrowed and piercing, the left wide open with a questioning and half quizzical lift to the eyelid, showed the shrewd ability which marked his career.

Bangor's Samuel Veazie was an industrial leader, a railroad magnate and one of the great lumber barons of nineteenth-century Maine. *Courtesy of Bangor Historical Society.*

This description of Samuel Veazie at age forty-five was by a contemporary. Even though he owned over fifty sawmills, Veazie was more than just a lumber baron. In addition to his sawmills, Veazie owned a bank, a newspaper, a railroad, a fleet of sailing ships, real estate in Bangor and thousands of acres of timberlands. Of all his numerous operations, the railroad was the one that gave him the most satisfaction, probably because it was the most profitable.

Samuel Veazie was born in Portland in 1787. As a young man, his first job was as a baker's apprentice. Bored with this life, he became a sailor aboard a vessel that traded in the West Indies. Showing acute business acumen, the youthful Veazie gained the rights to storage space on the vessel, which he filled with goods that he bought cheaply in Portland and sold at a profit in the West Indies. On the return trip from the West Indies, he brought back what he could sell profitably in Maine. In three years, Veazie had accumulated enough capital to buy his own craft. With this financial foundation, he bought more ships, and soon the young entrepreneur had a whole fleet transporting lumber to the West Indies and returning with goods to sell in Maine.

By the time the War of 1812 broke out, the energetic Veazie had become a wealthy businessman with a wife and five children. He joined a militia company and rose from ensign to general by the end of the war. Like his contemporary, governor-to-be William King, and William Hyde, who was a generation younger, Veazie was known as "the General" for the rest of his life.

In the 1820s, Veazie, who was usually ahead of the curve, recognized the profits to be made in the lumber business. He began to buy land and sawmills in the Old Town area north of Bangor, and within a few years he was the largest mill owner on the Penobscot River. "Land is all right and

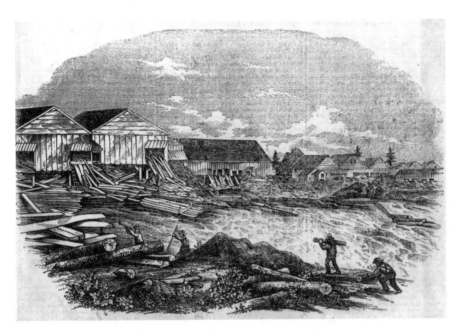

Sawmills on the Penobscot River at Old Town. Samuel Veazie owned over fifty sawmills in the Old Town and Bangor area. *Courtesy of Bangor Public Library.*

pine is all right," he was heard to say, "but it's the sawmills that make the money." There are estimates that he may have owned as many as eighty sawmills, although the actual total was probably closer to fifty. The mills ran twenty-four hours a day and employed as many as five hundred men.

Robert Pike wrote in *Tall Trees, Tough Men*:

> *The Penobscot [River] area was a lumberman's dream. There were two and a half million acres of the finest pine forest in the world that through a vast network of lakes and streams could be funneled down the West and East branches of the Penobscot to the countless sawmills in Bangor and the towns just above it.*

At its zenith, Bangor, known as the lumber capital of the world, was shipping 250 million board feet of lumber annually. More than three thousand ships arrived in Bangor each year, "lying so thick a man could walk on their decks from Bangor to Brewer on the other side," according to Pike.

In 1832, Veazie moved his family to Bangor, where he lived for the rest of his life. His first house was on Harlow Street, near present-day Abbott

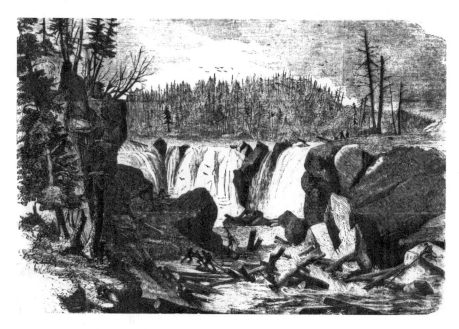

Shooting the falls. The interior of Maine was a lumberman's dream. A vast network of lakes and streams funneled timber down the east and west branches of the Penobscot River. *Courtesy of Bangor Public Library.*

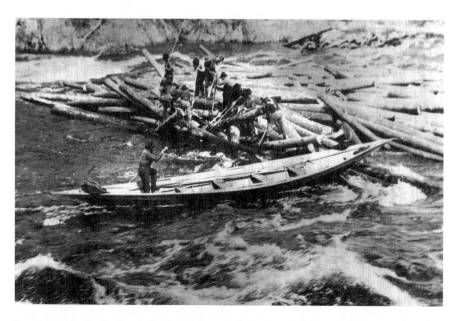

Logging was a dangerous and exhausting job, as seen in this picture of lumberjacks trying to break up a mid-river jam. *Courtesy of Bangor Public Library.*

Square. Later, he built a larger house on the corner of York and Broadway that became the Jerrard Hotel. (It was subsequently torn down and replaced by a supermarket and today is the location of Family Dollar.) In 1854, he moved four miles upriver to present-day Veazie, where he spent the summer, returning to Bangor for the winter months. There is an apocryphal story that when his Bangor neighbor, James Crosby, began to construct a building that looked as though it might eclipse his house, the General ordered his builders to add a third story. "I will not be looked down on by anybody," he is reported to have said.

Veazie enjoyed the feeling of being in charge, and his interests continued to expand. He acquired two log booms on the Penobscot, which allowed him to pretty much control logging activities on the river. (Log booms are giant pens that catch logs as they come downriver so that they can be sorted for their owners before being sold to the mills.)

In 1837, the General and several associates purchased a local newspaper, the *Eastern Republican*. The paper traditionally had supported liberal Democratic candidates and causes; that is, until Veazie and his partners bought it. As conservative Democrats, they were especially opposed to President Andrew Jackson's banking reforms. Although Veazie was not particularly interested in politics, he was on the Governor's Council for a term and served as an alderman of Bangor for two years.

Owning fifty-odd sawmills and two logging booms was not enough for the General. In 1836, following a successful lawsuit, he gained control of the Bangor & Piscataquix Railroad Co., the twelve-mile line that ran from Bangor to Old Town. Veazie once remarked that of all his ventures, the railroad was by far the most profitable. (Thoreau notes in his journal that he rode on it with his guide.) Under Veazie, the line prospered. He used it to transport passengers (the one-way fare was thirty-seven cents), as well as to haul lumber from Old Town mills to Bangor. He built three bridges over the falls at Old Town at his own expense and later extended the line across the river to Milford.

A man like General Veazie needed funds he could get at quickly to get the jump on the competition. To ensure that he had capital available, he bought the Bank of Bangor. When the bank's charter expired, he had it renewed, renamed it the Veazie Bank and appointed himself president and manager. Records show that the bank's board meetings, required by charter, were unusual, at least by modern standards. The meetings were held at Veazie's house with only the General in attendance. Business was transacted by unanimous vote.

Bill Caldwell wrote in *Rivers of Fortune*:

> *The Veazie Bank was one of the most reliable in the country. Even travelers to distant parts of the country felt secure carrying notes and currency issued by the Veazie Bank. When silver currency disappeared from circulation during the Civil War, the General stepped in and issued scrip of his own in 10, 25 and 50 cent denominations.*

Like many successful businessmen of his era, Veazie was often involved in lawsuits. In fact, the General relished a good court battle whether he won or lost. Shortly after he moved to Bangor, the local railroad line unwisely extended its track over his lands at Old Town. Veazie sued for damages and, in a jury trial, won a $17,000 settlement. As already noted, he soon gained control of the railroad.

In 1850, he challenged the State of Maine's right to grant an exclusive steamboat concession to a rival company on the Penobscot River. He lost the case, but in typical Veazie fashion, he refused to admit defeat. He had his steamboat dissembled, shipped to California, put back together and run on the Sacramento River at the height of the gold rush. The General ended up making more money than he ever would have on the Penobscot route. After the Civil War, the obstinate General claimed the right to keep issuing Veazie Bank currency, even though a new law prohibited banks from issuing their own money. Veazie took his case all the way to the Supreme Court, where he lost.

Another Veazie venture was the founding of his own town. By the 1850s, the population of Bangor had expanded rapidly. To cover services, taxes were raised to the point where many citizens objected to the high cost of living within the city limits. General Veazie stepped in and, in a brilliant move to reduce his taxes, persuaded the state legislature to approve the charter for a town that would be separate from Bangor. After a series of complex negotiations, the Town of Veazie was incorporated on June 27, 1853.

General Veazie died in March 1868 at his winter home in Bangor, just a few days shy of his eighty-first birthday. Shortly after his death, the Town of Veazie passed the following resolution:

> *The inhabitants of Veazie express their regret at the recent death of General Samuel Veazie to whom the town is indebted for its separate municipal existence and for its name—that they highly appreciate his character as a citizen and who, in his various relations with the town, has maintained a high character for fair and honorable dealing, won the confidence and regard of the people.*

THE "DEACON": GEORGE THOMAS BUILDS THE CLIPPER *RED JACKET*

There's a bustle in the shipyard of the builder Deacon Thomas,
A pounding of the hammers and a ringing of the forge;
A smell of tar and oakum and the tread of hustling feet,
And masts are standing stark and haughty, waiting for the sheet.
—from "Red Jacket," by Ethel Thomas Sezak,
great-grandniece of George Thomas

The ship *Red Jacket* was named for a Seneca chief who fought with the British during the American Revolution. He was rewarded for his services with a red coat, which he wore proudly for the rest of his life. The ship's builder was "Deacon" George Thomas, who was born into a shipbuilding family on North Haven Island in 1795. In the 1820s, Thomas moved to Rockland, where he built twenty-five ships before he received the *Red Jacket* order. The clipper would receive international acclaim as the "fastest and handsomest ship in the world."

We are familiar with the phrase "going at a good clip," meaning to go fast. During the Napoleonic Wars and the War of 1812, American ship designers began to build privateers that "dictated some daring departures in ship design," wrote Dr. Lawrence Allin in an essay on shipbuilding in Maine. A premium was placed on building speedy vessels that could escape from British warships.

It was not until the late 1840s, however, that true clipper ships, the "greyhounds of the sea," began to appear. The discovery of gold in California, followed by the 1851 gold rush in Australia and a burgeoning trade with China, triggered the need to get places in a hurry. In fact, the term "clipper" was not used unless a vessel could make the run from New York to San Francisco in 110 days or less. (Remember, this was before the Panama Canal was built.) Because clippers carried so little cargo, their long, narrow hull designs became less popular, and schooners replaced them. In 1857, there was a major depression followed by the Civil War, which pretty well ended the clipper ship era.

Maine was building a lot of ships in the mid-nineteenth century, although most were not of the clipper design. Labor was less costly than in Boston and New York yards, thus Maine builders got the bulk of the orders. Between 1850 and 1857, 2,255 large vessels were built in the United States, and well over half of them were constructed in Maine. Interestingly, of the 444

In 1853, George Thomas built the clipper ship *Red Jacket* in his Rockland shipyard. Thomas had built twenty-five ships by the time *Red Jacket* was launched. *Courtesy of Rockland Public Library.*

clipper ships that were built during this period, only 71 were built in Maine. Ten clippers, however, including *Red Jacket*, were launched in Rockland between 1851 and 1855.

The master clipper builder of the day was Nova Scotia–born Donald McKay, who worked out of a yard in East Boston, Massachusetts. His famous *Flying Cloud* epitomized the clipper ship. In 1852, in what must have been a snub for McKay, the Boston shipping firm of Seacomb and Taylor decided to give the design of a new vessel to twenty-five-year-old Samuel Pook. Pook's father was a respected shipbuilder, and his son grew up "in an atmosphere steeped in ships," according to an article by Ben Fuller in *Maine Boats, Homes and Harbors* magazine. By 1852, Pook had already designed two full-rigged clippers (*Defiance* and *Rattler*) that were built by George Thomas. *Red Jacket* would be the largest and fastest of the three.

George Thomas grew up on North Haven Island in Penobscot Bay, then known as the North Island. The year 1819 was an eventful one for the Thomas family. The family schooner *Thomas*, built by George and his father, Peleg, was lost at sea while carrying a cargo of limestone. Thomas's uncle Joshua and his older brother Benjamin went down with the ship. On a more positive note, George Thomas married Peggy Vinal, who was also from the North Island.

In the early 1820s, the couple moved to Rockland, where Thomas established a shipyard at the north end of Rockland Harbor. He acquired the title of "Deacon" because of his many years as a deacon for the First Baptist Church of Rockland. In 1851, Thomas also helped to organize the Second Baptist Church.

The famous ship that the Deacon Thomas yard would produce in 1853 owed its graceful lines to young Samuel Pook, who had developed a reputation as a "genius of marine design." The vessel's good looks came from

its concave sides and ends, which were very long and sharp. (This style would be widely copied by later builders.) With the life-size figurehead of a Seneca chief on the bow and a rounded stern covered with heavy gilt scrollwork, it was considered "the handsomest of the large clippers put afloat," according to a reporter for the *Rockland Gazette*.

The English marine historian Basil Lubbock wrote that *Red Jacket* was more beautifully modeled than Donald McKay clippers and that its strength was disguised under graceful curves. Howe and Matthews, in *American Clipper Ships*, commented:

> *The extreme clipper ship* Red Jacket *was justly celebrated for the graceful beauty of her lines. Her arched stem was as pleasing to the eye as was her powerful, but exquisitely modeled stern, while her spars and rigging were perfectly proportioned.*

The three-decked, 2,305-ton *Red Jacket* was 260 feet long, with a 44-foot beam and a depth of 31 feet. It was manned by a crew of sixty-two. Its accommodations—two cabins and fourteen staterooms—were described as "of the finest in decoration and comfort." The rooms were paneled in rosewood, mahogany and zebra wood set off with black walnut and gilding.

A postcard of the clipper ship *Red Jacket*. In 1854, *Red Jacket* set a record for the fastest Atlantic crossing by a sailing ship. *Courtesy of Rockland Public Library.*

Red Jacket was the largest vessel, by fifty feet, and heaviest, by seven hundred tons, launched to date in Rockland. The ship's launching on November 4, 1853, attracted thousands of spectators. Local businesses and schools were closed. *Red Jacket*'s momentum was such that on hitting the water it swept across the harbor to a pier where the schooner *Warrior* was loading a cargo of limestone. A member of the crew, John Lothrop, saw it coming and grabbed an oar, hoping to fend off the huge vessel. A wiser shipmate yelled, "Jump!"—which fortunately Lothrop did at the last minute. *Red Jacket* hit *Warrior* with such force that the schooner's side was stove in and several barrels of lime were forced out of its hold. *Red Jacket* was not damaged, although it is not hard to imagine the reaction of *Warrior*'s owner.

Captain Isaac Taylor was a Bostonian who knew Deacon Thomas to be a reliable shipbuilder. Taylor may have also suggested the name *Red Jacket* for the vessel. A Boston sculptor carved a life-size figurehead of the famous Seneca chief Sagoyewatha ("He who keeps them awake"), who had supported the British during the Revolution. (When his first red coat wore out, he was given a second and, in 1794, yet a third.)

As a young man, Sagoyewatha was known for his fleetness of foot, his intelligence and his ability as an orator. As a sachem (chief), Red Jacket feared the disappearance of Native American culture with the advance of the white man. After the Revolution, he traveled to Philadelphia, where he negotiated a peace treaty for the Iroquois tribes. In recognition of his assistance, George Washington presented Sagoyewatha with a silver medal.

Interestingly, Red Jacket sided with the United States in the War of 1812. At one point, he secured the release of one of Captain Taylor's relatives, who had been captured by the British. In return, the grateful Taylor family promised to name a ship after the old chief. Red Jacket spent his last years in a log cabin near Buffalo, New York. He died of cholera in 1830, well before his famous namesake was built.

Red Jacket's bottom had not yet been copper-sheathed, and its paint was scarcely dry when its owners decided to send it to Liverpool for a mid-winter sale to the British. On January 10, 1854, amid rain, snow and hail, *Red Jacket* set out on what was to be a record-breaking Atlantic crossing. The ship was under the command of Asa Eldridge, a superb transatlantic navigator from Yarmouth, Massachusetts. In spite of bad weather, and with a crew that he termed "indifferent" and "incompetent," Eldridge drove the ship hard. The gritty captain remained on deck throughout the voyage. He had his meals brought up to him and only occasionally rested in an armchair lashed to the deck.

The Seneca chief Sagoyewatha was named "Red Jacket" for the coat given him by the British during the American Revolution. He is shown wearing a medal given to him by George Washington for his assistance in making peace. *Courtesy of* Maine Boats, Homes and Harbors *magazine, Rockland, Maine.*

It is difficult to imagine how grueling it must have been to sail a ship to a record run through the gales of a North Atlantic winter. The clipper managed only 103 miles the first day, but then the wind picked up. At one point, *Red Jacket* averaged 343 miles, or 14.3 knots, per hour for six consecutive days. It

made its best run on its ninth day, with 413 miles. The pride of Rockland, Maine, arrived in Liverpool, having broken the old record for an Atlantic crossing by twenty-five hours. (The old record had been set six months earlier by *Sovereign of the Seas*.) *Red Jacket*'s record of thirteen days, one hour and twenty-five minutes would never be surpassed by a commercial sailing vessel.

When *Red Jacket* arrived at the Mersey River estuary outside of Liverpool, Eldridge was offered a tow by two tugs, which he ignored. Instead, with thousands lining the waterfront, he demonstrated his superb seamanship. *Red Jacket* sped through the harbor and up to the dock under full sail. When the ship was abreast of the pier, he brought it up into the wind, dropped the sails and actually backed the ship up to the pier with such precision that it brought a roar of applause from the crowd. "Not one master in a hundred would have dared try it," wrote an enthralled spectator. It was a fitting climax to a remarkable passage.

Red Jacket was first chartered, and later sold, to John Pilkington and Henry Wilson, founders and owners of the White Star Line of Liverpool. It entered the Australian packet service, during which time it made several more record-breaking passages. The illustrious clipper sailed the seven seas for another thirty-two years but never returned to the United States.

> *There's the roaring cheer of welcome from the dock by English tars,*
> *As they greet the fastest clipper to fly the Stripes and Stars;*
> *And Rockland hearts are happy this bright January day,*
> *As they clasp the hand of George Thomas, who sent her down the way.*
> —Ethel Thomas Sezak

Part IV

THE CIVIL WAR AND BEYOND

THE ADMIRAL: JAMES ALDEN AND THE BATTLE OF MOBILE BAY

The waters of the bay were calm early on the morning of August 5, 1862, as Union warships approached Fort Morgan. The fort stood at the entrance to the important Confederate port of Mobile, Alabama. The lead ship in the second column was USS *Brooklyn*, commanded by Captain James Alden, a native Mainer. During the course of the battle that followed, Alden cautioned David Farragut, commander of the Federal fleet, that mines—or torpedoes, as they were called in those days—lay ahead. At this point, Farragut is supposed to have uttered his famous response: "Damn the torpedoes, full speed ahead," which has since become a memorable phrase in American battle lore. Alden went on to play a major role in the fight that followed.

James Alden was born in Portland in 1810, when Maine was still a province of Massachusetts. His father, John Alden, was the namesake and a direct descendant of one of the leaders of the Mayflower Expedition that landed at Plymouth in 1620. His uncle, George Tate, was an admiral in the Russian navy, but that is another story.

Young Alden entered the U.S. Naval Service in 1828 and served onboard two ships as a midshipman before he was "passed midshipman" in 1834. (The United States Naval Academy was not founded until 1845. Prior to that time, young men pursuing a naval career were trained on shipboard and at shore establishments under senior officers.) For the next thirty-eight years, Alden served the navy in a variety of capacities and on

James Alden served all over the world during a long and distinguished naval career. He fought in the Mexican War and for the Union in the Civil War. *Courtesy of Special Collections and Archives Department, Nimitz Library, United States Naval Academy, Annapolis, Maryland.*

a variety of ships. Shortly before his retirement in 1872, Alden was promoted to rear admiral.

Alden's first assignment was in 1835 at the Boston Navy Yard, where he worked until 1838. He then received orders to join the South Seas Expedition, also known as the World Exploration Expedition, led by Lieutenant Charles Wilkes. During the next four years, Wilkes and his crew explored the Pacific from Puget Sound to Hawaii to Antarctica. During the course of the explorations, Wilkes named numerous islands that he "discovered" in the Pacific after members of his crew. Wilkes was a ruthless captain, however, and when several officers, including his nephew, died following a clash with native tribes in the Fiji Islands, he responded by killing eighty Fijians. The expedition returned to the United States by way of the Philippines, Singapore and the Cape of Good Hope, reaching New York on June 10, 1842.

For the second time in four years, the navy sent Lieutenant Alden on a cruise around the world. In 1844, he was assigned to the venerable warship USS *Constitution* on its thirty-month circumnavigation of the globe. The expedition was under the command of Captain John "Mad Jack" Percival. Percival lived up to his name when he ordered Alden to attack several war junks while the fifty-year-old *Constitution* lay under the guns of a fort in Cochin, China. It was the first military action taken by the United States in the Far East.

By the end of the Mexican War (1848), Alden had become an expert surveyor. Following the war, he was assigned to serve on a United States Coastal Survey team with orders to map the East Coast of the United States.

The following year, Alden was sent to California and given command of the Coastal Survey ship *Active*. Alden spent the next six years in the far west, surveying and mapping the Pacific coast.

During this time, two additional events occurred that are worthy of mention. In 1856–57, Alden played an important role in quashing a disturbance in the Washington Territory. *Active* and two other American ships sailed to Puget Sound, where their presence reassured settlers and reduced tensions with the Native American peoples of the Puget Sound area.

Two years later, in 1859, Alden and *Active* were again in the news. This time, the problem was a boundary dispute between American and British authorities in the Pacific Northwest. The area in question was the San Juan Islands, which lie between Vancouver Island and the North American mainland. The so-called Pig War resulted when an American shot an Englishman's pig. When Alden arrived, he quickly diffused the situation, and the conflict ended with the pig as the war's only casualty.

The outbreak of the Civil War in 1861 found Alden in command of USS *South Carolina*. He was sent to Florida with orders to fortify Fort Pickens to keep it from falling into Confederate hands. Fort Pickens sits on an island off Pensacola Harbor and had been in disrepair since the end of the Mexican War. Alden was directed to resupply and help defend the fort. Despite repeated Confederate attempts to capture it, the vital post remained in Union hands throughout the war.

Alden saw his first real action of the war early in 1863 as a member of the West Gulf Blockade Squadron, which was led by the irascible Union admiral David Farragut. Alden ran his ship, USS *Richmond*, past the Confederate batteries at Forts Jackson and St. Philip and up the Mississippi as far as Port Hudson and Vicksburg. For these and other services, Alden was promoted to captain in June 1863. Subsequently, he assumed command of USS *Brooklyn*, on which he would achieve his greatest fame as a naval officer.

And so we return to the morning of August 5, 1864, and the Battle of Mobile Bay. After the fall of New Orleans in 1862, Mobile was the last major port on the Gulf of Mexico remaining in Confederate hands. The city was vitally important to the South as a center for blockade running. By 1864, most of the trade between the Confederacy and the outside world passed through Mobile.

The commander of the Union fleet, Admiral Farragut, was faced with a formidable challenge. The entrance to Mobile Bay was extremely narrow due to a series of barrier islands that stretched most of the way across the entrance

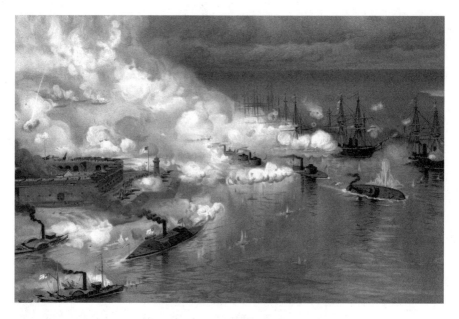

The Battle of Mobile Bay, August 5, 1864. The Union fleet, on the right, is shown steaming past Fort Morgan and several Confederate ironclads. The lead Union monitor, *Tecumseh*, has just hit a mine. *Painting by J.O. Davidson. Courtesy of Anne S.K. Brown Military Collection, Brown University Library.*

to the bay. To make matters worse, Southern defenders had placed dozens of torpedoes (or mines) in the channel. The effect was to force the Northern fleet to sail close to shore, within easy range of the batteries at nearby Fort Morgan.

As Alden was entering the channel in USS *Brooklyn*, he saw the buoys marking the minefield ahead and signaled his concern to Farragut. The impatient admiral ordered him to "go ahead." As the two officers were exchanging messages, shells from Fort Morgan rained down on them. At that moment, the Union monitor *Tecumseh*, commanded by Alden's childhood friend Captain Tunis Craven, struck a mine and went down in less than a minute. Alden ordered his ship to back up to avoid the minefield and called across the water to Farragut that there were "torpedoes dead ahead." It was in response to this that Farragut gave his famous order.

Alden later paid homage to his friend Craven and his shipmates when he wrote, "It was a glorious, though terrible end for our noble friends. Immortal fame is theirs! Peace to their names." Only 21 of the 114 members of *Tecumseh* crew survived.

Curiously, the actual comment by Farragut—"Damn the torpedoes"—did not appear in popular accounts of the battle until several years later. Those

onboard his flagship, USS *Hartford*, doubted whether verbal communications could have been heard above the din of battle. The reality of the situation, however, was that Farragut had little choice but to forge ahead. He could not sit under the guns of Fort Morgan, nor could he reverse direction and risk a collision with the ships following behind him.

There were sailors onboard the ships that followed Farragut and Alden into Mobile Bay who claimed they heard fuses breaking off the torpedoes as they passed through the minefield. Luckily, only the mine that *Tecumseh* hit exploded. Once past Fort Morgan, Captain Alden and his crew distinguished themselves in the battle with Confederate ironclads that followed. Farragut's satisfaction was evident in his report of the battle when he wrote: "I have reason to feel proud of the officers, seamen and marines of the squadron under my command."

Did Admiral Farragut know more about the condition of the torpedoes than he was letting on? The question is worth asking. The night before the attack, he sent a team to reconnoiter the channel. Word came back from refugees, deserters and others that most of the mines had been in the water so long they were probably harmless. It would appear that Farragut felt it was worth the risk to take his fleet through the minefield.

In the years following the Civil War, Commodore Alden was put in charge of the naval shipyard at Mare Island, California. After this, he ran the Bureau of Naval Navigation in Washington for a year. Following his promotion to rear admiral in 1871, Alden was made commander of the navy's European Squadron until his retirement the next year. In 1877, James Alden was in San Francisco when he died suddenly at the age of sixty-seven. His body was returned to his native Portland, Maine, where he is buried.

In 1918, the destroyer USS *Alden* was launched in Philadelphia, Pennsylvania. Named for Admiral James Alden, the ship saw extensive action throughout World War II. At the end of the war, the ship was awarded three battle stars for its services.

THE GENERAL: THOMAS HYDE AND THE BATH IRONWORKS

At the time of his death in 1899, General Thomas Hyde was one of Maine's leading citizens. In modern parlance, "he had done it all." An 1861 graduate of Bowdoin College, he rose to the rank of brigadier general by the end of

the Civil War. He returned to Bath, where he spent the rest of his life. Hyde served three terms in the state senate and was its president in 1876. He was a two-term mayor of Bath, and in 1884 he incorporated the Bath Ironworks, which was to become one of the major shipyards in the United States. Hyde was president of the yard until his death in 1899.

Hyde's parents were on a two-year grand tour of Europe when their only son was born in Florence, Italy, in 1841. They returned to Bath shortly after his birth, and he was educated at local schools. Hyde's elderly father was in poor health, and he died shortly before his son entered Bowdoin. Hyde sounds like a typical college student in a letter he wrote to his mother: "There is scarcely anything to write from this stupid place!" And in another letter, perhaps responding to his mother's concern, he wrote: "I keep to my room all the time and study hard."

In 1860, the future general headed west to do postgraduate work in technology at Chicago University. While there, he met Abraham Lincoln, as well as Lincoln's vice president to be and fellow Mainer Hannibal Hamlin. Hyde was a volunteer clerk for Lincoln and impressed the president-elect enough to be invited to accompany him to Washington. "Heady stuff for a college boy barely twenty years old," wrote Ralph Snow in *Bath Iron Works*.

The next few months were a whirlwind of activity for Hyde. When Fort Sumter was fired on in April 1861, he joined the Chicago Zouaves, a local militia unit with colorful uniforms. When not attending classes, he practiced their elaborate and complex set of drills. Hyde resigned from the unit, however, when they were not called to active duty. Instead, he rushed back to Maine and finished up his studies at Bowdoin.

Hyde missed his Bowdoin graduation because he and some of his pals were already in Augusta organizing a volunteer unit that was to become the Seventh Maine Volunteers. Hyde was elected major of the regiment "because [thanks to his experience with the Zouaves] I was the only man in the regiment who could drill a company." He subsequently wrote to his mother: "I did not know that my principle duties were to ride the flank of the rear division, say nothing, look as well as possible, and long for promotion."

The Seventh Maine Volunteers were soon needed at the front. The regiment lacked a colonel, which meant that twenty-year-old major-elect Thomas Hyde led his men down to Washington, where they were attached to George McClellan's Army of the Potomac. Hyde was ambitious, "but only if I deserve it," he wrote home. Later he confided, "I have been in command for some time and am bound to be a general before the war is over. Don't laugh, I mean it."

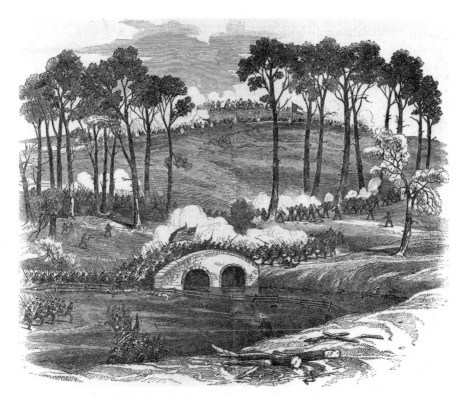

The Battle of Burnside's Bridge was part of the Battle of Antietam, where Hyde's regiment was heavily engaged. Hyde saw action throughout the Civil War and emerged a general at age twenty-four. *Courtesy of Library of Congress, Prints and Photographs Division.*

Hyde saw action in many important Civil War battles, though his first engagement was inauspicious. Near Newport News, Virginia, he was awakened in the middle of the night by a barrage of gunfire. Rushing up to the front line, Hyde found that his nervous guards had killed two Confederate cows and an old horse.

In 1862, Major Hyde commanded the Seventh Maine Regiment at the Seven Days Battles around Richmond and at the Second Battle of Bull Run. Later the same year, at Antietam, he had three horses shot out from under him. Only sixty-five of his men and three officers, including Hyde, came through the bloody battle unscathed. Major Hyde had a close call when "my leg was benumbed by a shell passing too close… Don't be alarmed," he wrote to his mother. "Something tells me I have other uses to perform. The boys will have it that I have a charmed life." And indeed he did.

Hyde received the Medal of Honor following Antietam. The citation read as follows:

He led his regiment in an assault on a strong body of the enemy's infantry and kept up the fight until the greater part of his men had been killed or wounded, bringing the remainder safely out of the fight.

Major Hyde served under General Sedgwick at the Battle of Gettysburg, and he was with the general at Spotsylvania when Sedgwick was killed. At twenty-three, Hyde was promoted to colonel and commanded a corps under General Sheridan. Then, in 1864, he led his men in the assault that broke the Confederate lines at Petersburg. Hyde could be a tough officer, however. When he found a soldier who wouldn't fight, he took out his sabre and slashed him in the leg. "That seemed to bring him to his senses," Hyde later recalled.

The ubiquitous Colonel Hyde was present when Lee surrendered at Appomattox in 1865, ending the war. Before he was mustered out, Hyde was promoted again, and it was as a general that twenty-four-year-old Thomas Hyde led his men down Pennsylvania Avenue in the Grand Review at the end of the war. The legendary Maine general and future governor of the state Joshua Chamberlain's remark bears repeating: "Commanding is young general Tom Hyde, prince of officers, cool of head, sweet of soul."

Back in Bath, the man now known as "the General" resumed civilian life. He married Anne Hayden, and to support his growing family (they were to have six children), he leased a small iron business. He began with seven men on the payroll and produced ship machinery. Hyde expanded into the iron supply business and was soon a prominent and wealthy member of the Bath community. The General sat on the boards of a bank and the Maine Central Railroad. As previously noted, he was a state senator and then mayor of Bath.

As his business grew, Hyde invented and patented the Hyde Windlass, a machine that became standard equipment for raising ship's anchors. By the 1880s, sales of the Hyde Windlass and other marine machinery were growing to the point where Hyde felt he was in a position to transform the Bath Iron Foundry into Bath Ironworks, which he did in 1884.

General Hyde felt strongly that for Bath to remain a vital community, the town must provide jobs for its citizens. As he said in a speech while mayor, "We should therefore encourage and put forward our young people in every way while their energy and ambition are unclouded…the enterprise of a comparatively small number of men keeps the city alive." As Garnett Eskew

Following the Civil War, General Hyde returned to Maine and became a prominent member of the Bath community. In 1884, he founded the Bath Ironworks. *Courtesy of Maine Maritime Museum, Bath, Maine.*

wrote in *Cradle of Ships*, "Were it not for the Bath Iron Works, generations of young men would have found little reason to seek work at home."

Hyde was an astute businessman, and he could see profits in the new and growing business of iron shipbuilding. Beginning in the 1880s, his yard began to bid for contracts to build steel ships. In 1890, the ironworks won its first contract to build two steam-powered ironclad gunboats for the United States Navy. The 190-foot-long *Machias* was launched in 1891 and its sister ship, *Castine*, the next year. Both vessels saw action in the Spanish-American War and World War I.

Although the navy has historically been its best customer, the Bath Ironworks has also built private and commercial vessels. In 1892, the yard won a contract for a commercial steel craft, the twenty-five-hundred-ton passenger steamer *City of Lowell*. The ship was completed in 1894 and for a time held the record as "the fastest vessel on the Sound." In the following decades, the company went on to build a number of luxury yachts for wealthy sailors.

In the winter of 1898, General Hyde went to Cuba following the sinking of USS *Maine*. An article in the *New York Times* quotes him as feeling that war with Spain was inevitable: "I cannot see anything ahead but a clash of arms." The old soldier felt strongly that the Spanish were responsible for the sinking of USS *Maine*. "There is no doubt in my mind that it was the work of the Spaniards. We didn't do it. The Cubans didn't do it. They couldn't. The *Maine* was blown up with a Spanish mine."

The article concluded by saying that Hyde favored making Cuba a colony of the United States. More than a century later, the cause of the explosion continues to generate controversy. Was it internal combustion from the coalbunker located next to the powder magazine, or was a mine detonated outside the ship's hull?

Castine was the second of two 1,177-ton gunboats built at the Bath Ironworks. It was launched in 1892 and saw action in the Spanish-American War and World War I. *Courtesy of Maine Maritime Museum, Bath, Maine.*

General Hyde's health began to fail in 1898, and in 1899 he died of Bright's disease. That year, his yard began work on construction of USS *Georgia*, the only battleship ever to be built at Bath. It took five years to complete *Georgia*. At the time of its launching, *Georgia* averaged nineteen knots in its sea trials, making it the fastest battleship in the navy. The fourteen-thousand-ton *Georgia* was a member of the famous Great White Fleet of sixteen battleships that President Theodore Roosevelt sent around the world in 1907–8.

In the past century, the shipyard that General Hyde founded has filled more than 425 shipbuilding orders, including 245 for the U.S. Navy. Referring to Hyde, Henry Wilson Owen wrote in "The History of Bath, Maine": "The Bath Iron Works is a monument to his business ability. He will also be remembered as a soldier, financier, statesman, literateur and a scholar."

The Civil War and Beyond

THE INVENTORS: MARGARET KNIGHT AND HIRAM MAXIM

Margaret Knight and Hiram Maxim were two of the most brilliant and prolific inventors of the nineteenth and early twentieth centuries. Although their inventions were very different, they were from similar backgrounds. Each was born in Maine and came from modest circumstances. They were almost exact contemporaries, born two years apart. Interestingly, each died at the age of seventy-six. Margaret Knight spent most of her life in Massachusetts, whereas Horace Maxim immigrated to England in 1881 and became a British citizen.

Margaret Knight

Margaret Knight was born in 1838 in York, Maine. Her father died when she was very young, leaving Margaret and her two older brothers to be raised by their mother, who moved to Manchester, New Hampshire. Margaret—or "Mattie," as she was called—liked building things and enjoyed making toys for her brothers. One winter, she made a foot warmer for her mother and sleds for both of her brothers.

At the age of twelve, Margaret went to work in a textile mill. Later that year, she witnessed an accident in the mill that changed her life. A snagged thread caused a spindle to fly off its moorings on a loom, seriously injuring one of her co-workers. Margaret went to work and produced a safety device called a covered shuttle. The result was an invention that caused the machine to stop automatically if something got caught in it. Margaret's invention quickly became standard on all looms.

After the Civil War, the thirty-year-old Knight moved to Springfield, Massachusetts, where she took a job with the Columbia Paper Bag Company. It was here that she developed what is considered to be her greatest invention. Knight saw how hard it was for shoppers to carry their purchases in the bags currently being used. Her idea was to build a machine that would make flat-bottomed bags to replace the flimsy, envelope-style bags of the day.

Knight proposed the idea to her boss, and with his encouragement, she went to work. She studied the machines in the factory during the day. At night she made drawings and models in the boardinghouse where she was living. Throughout the process, Margaret had to deal with the skepticism of her male co-workers, many of whom refused to accept the idea that a woman knew anything about machines.

The jacket design from *Marvelous Mattie: How Margaret E. Knight Became an Inventor*. Text and pictures by Emily Arnold McCully. *Reprinted by permission of Farrar, Straus and Giroux, LLC.*

It took Knight a year of testing before she was satisfied with her invention. She built a wooden model of the device, but she needed an iron model to apply for a patent. As Margaret was waiting for her patent to be accepted, Charles Annan, a co-worker who reportedly claimed that a woman could not possibly have invented such a complicated machine, stole the design.

Apparently, Annan had secretly watched her building the iron model and rushed to patent it himself. In 1873, Knight took Annan to court and won a successful patent interference suit by showing her designs, notes and models. She produced 1,867 drawings to support her case. Margaret Knight's invention revolutionized the paper bag industry by replacing the work of thirty people with one machine.

In 1870, Margaret founded the Eastern Paper Bag Co. in Hartford, Connecticut, in partnership with a Massachusetts businessman. As a result, she finally began to receive royalties on her invention, which was having a huge impact on the paper industry. Businesses from the corner grocer to large department stores soon realized how much more efficient it was to package a customer's purchase in a flat-bottomed bag rather than wrapping it with paper and string. Margaret Knight continued to refine her paper bag design over the years.

It is well known that the nineteenth century was a time when women had to constantly struggle to receive recognition for anything they achieved outside the home. Margaret used the sexism of her male counterparts as a spur to work that much harder. She was unusual in that, unlike most female inventors at this time, her inventions were not confined to household improvements.

The woman who became known as "the female Edison" did not stop with paper bags. She received patents for such diverse inventions as an adding machine, a window frame and sash, a machine for cutting shoe soles and several improvements to the internal combustion engine. Margaret Knight continued inventing for the rest of her life. She received over eighty patents and conceived of dozens more inventions.

A plaque that recognized Knight as the first woman in the United States to hold a patent hangs in a corner of Curry Cottage, where she lived in Framingham, Massachusetts, for the last twenty-five years of her life. In fairness, however, it should be noted that Mary Kies was actually the first female recipient of a patent granted by the United States. In 1809, Mary developed a technique for weaving straw with silk and thread, which made women's hats more cost-effective.

Throughout her career, Knight tended to sell her inventions to the company that currently employed her. As a result, she never made much of a profit from her inventions. When she died in 1914, her estate was only worth $275. Margaret's original bag-making machine is in the Smithsonian Institution in Washington, D.C. In 2006, Margaret Knight was the first woman to be inducted into the Paper Industry Hall of Fame in Appleton, Wisconsin. As of 2009, she was one of only two women among the ninety-five inductees.

Sir Hiram Maxim

Whatever happens, we have got
The Maxim gun, and they have not.

Hiram Maxim was born in 1840, which makes him junior to Margaret Knight by two years. Unlike Ms. Knight, Hiram came from a family of inventors. By the late nineteenth century, the name Maxim was internationally known, primarily because of his work on the machine gun that bore his name.

Hiram grew up on a farm in Sangerville, Maine, where he received an elementary school education. His father's primary job was that of a mechanic, so as a youth Hiram was constantly seeing how things worked. At the age of fourteen, he was apprenticed to a carriage builder. A few years later, he went to work in his uncle's machine shop in Fitchburg, Massachusetts.

Maxim moved to Boston in 1866, where he was employed in a shop that made scientific instruments. It was here that he received his first patent, for an electric curling iron. A few years later, he took a job at the United States Electric Lighting Company, where he rapidly rose to the position of chief engineer. Hiram had meanwhile become a prolific inventor. Of particular note were the locomotive headlight and his invention for a new type of filament for the incandescent light. In the 1870s, Hiram developed and installed electric lights in the Equitable Insurance Building, marking the first use of electricity in a New York City building. During this time, he was also involved in a lengthy, and ultimately unsuccessful, patent dispute with Thomas Edison over the invention of the light bulb.

It was during these years that Hiram was beginning to tinker with the invention that would make him rich and famous. The Gatling gun was a primitive machine gun that had been invented by Richard Gatling in 1861. It was capable of firing a then-phenomenal two hundred rounds per minute. Maxim thought he could improve on the design and took his ideas to the War Department in Washington. His plans aroused little interest, so in 1881 Maxim set sail for England.

When Maxim was in Vienna the next year, he met a friend from the United States. According to Maxim, his friend told him, "Hang your chemistry and electricity! If you want to make a pile of money invent something that will enable these Europeans to cut each other's throats with greater facility."

The Gatling gun was a primitive machine gun used by Union forces in the Civil War. In 1883, Hiram Maxim invented a more reliable automatic weapon that was used in the First World War. *Author's collection.*

As a child, Hiram remembered having been knocked over by the recoil of his father's rifle. Using the recoil principle, he began to experiment on ways to use a gun's backward thrust to operate it automatically. In 1883, Maxim developed and patented an improved machine gun that used the energy from each bullet's recoil to eject the spent cartridge and insert the next one. The result was a gun that could theoretically fire over six hundred rounds per minute. His gun was water-cooled and fed by a belt of ammunition. Maxim later developed a smokeless cartridge, which further improved the effectiveness of the new weapon. And, unlike the Gatling gun, it did not jam.

Maxim founded an armaments company to produce and market his invention. In 1896, his company merged with the Vickers Corporation, with Maxim as one of the directors. Hiram sold the weapon to the British army, although there were many in the War Office who remained skeptical of the weapon's effectiveness on the battlefield.

The British first used the Maxim gun in their colonial wars in Africa. Despite being awkward to use and requiring a team of four to six men to operate, the effects of Maxim's gun were devastating. When it was used

Hiram Maxim shown piloting a steam-powered airplane that in 1893 briefly got off the ground. Maxim went on to invent hundreds of items. *Courtesy of Library of Congress, Prints and Photographs Division.*

against African tribesmen in the Matabele War (1893–94), fifty British soldiers held off five thousand warriors using four Maxim guns.

Both sides in the Russo-Japanese War (1904–5) used the Maxim gun, and it was estimated that 50 percent of all casualties were from the weapon. Other countries, including Germany, soon expressed interest, and during the First World War, all the Great Powers used improved versions of the Maxim gun.

Hiram Maxim went on to invent hundreds of items ranging from a mousetrap to a gas motor. At the turn of the century, he devoted much time and money to aeronautical experiments. He even built a steam-powered airplane that briefly got off the ground. In 1901, shortly after he became a naturalized British citizen, Queen Victoria knighted him.

Sir Hiram Maxim was a gifted and versatile inventor, though his colleagues and family found him almost impossible to get along with. Maxim received 122 patents in the United States and 149 from Great Britain during his lifetime. He died in 1916 in London in the middle of World War I.

The Civil War and Beyond

THE BALLPLAYER: GEORGE "PIANO LEGS" GORE

There have been seventy-one men from Maine who have played Major League Baseball. Bob Stanley won 115 games for the Red Sox from 1977 to 1989 and is probably the most successful big-league pitcher the state has ever produced. George Gore, who played in 1,310 games from 1879 to 1892 and had a lifetime batting average of .301, is arguably the best position player from the state.

Nicknamed "Piano Legs" because of his thick calves, Gore was born in Hartland, Maine, twenty miles east of Skowhegan. George, who showed up barefoot for his professional tryout, was a country boy who turned out to be a very good ballplayer. Indeed, Gore is the only Mainer to have ever won a Major League batting championship, which he did in 1880 with an average of .360.

Early baseball in Maine is closely tied to what was being played on the Boston Common in the middle of the nineteenth century and was known as the "Massachusetts Game." The game was similar to rounders and was played on a square field with four bases that were much closer than the ninety feet they are today. The batter stood between the first and fourth bases, there were no foul balls and anything hit was in play. Runners could be retired by "soaking"—being hit with a thrown ball.

Portland appears to have been the center of Maine baseball in the middle of the nineteenth century. The first actual reference to a team from Maine was on September 9, 1858, when nine from Portland defeated the Boston Tri-Mountain Club 47–42 on the Boston Common. Tri-Mountain was Boston's first professional team, so from this we can deduce that the Portland team must have been pretty good.

Before examining Gore's career, however, it is important to place it in the context of the rules he played under during the latter part of the nineteenth century. With the exception of the designated hitter rule used in the American League since 1973, the rules of baseball have changed very little since 1900. This was not true in the nineteenth century, when the game was constantly evolving. For example, until 1884 pitchers threw underhand, often from a running start and from a distance of forty-five feet. Two perfect games were thrown in 1880, when pitching completely dominated the sport. Incidentally, Gore won the batting championship that year, hitting .360 when the league average was a lowly .245.

In 1884, the pitching distance was moved back to fifty feet to give hitters more of a chance. Baseball historian John Shiffert states that the underhand

George Gore demonstrating his hitting technique in 1888. Gore was one of the outstanding ballplayers of his era. *National Baseball Hall of Fame Library, Cooperstown, New York.*

pitching technique of the day was similar to fast-pitch softball, except the ball was smaller. This means that a seventy-four-mile-per-hour fastball thrown from forty-five feet was equivalent to a one-hundred-mile-per-hour fastball delivered from sixty feet, six inches.

Gore probably used a glove toward the end of his career, although except for catchers, gloves were not common (they were considered "unmanly") until the 1890s, and then they were tiny. When Gore's career began, it took nine balls to get a walk. In fact, the present four-ball rule was only in effect for his last four seasons, and the present pitching distance of sixty feet, six inches was not established until after he retired. With the pitcher standing so close to the hitter, walks were obviously hard to come by, yet Gore led the league in bases on balls three times, including one hundred in 1886 and over seven hundred for his fourteen-year career.

As a young man, George Gore grew up playing ball around Hartland before going to work at the S.D. Warren Paper Mill in Westbrook, Maine. His exploits for the Warren team caught the attention of pro scouts, and in 1877 he signed a contract with Fall River, Rhode Island, in the New England League. Playing for the New Bedford Whalers the following year, Gore hit .324 and helped them win the New England championship. Suddenly, scouts from seven Major League teams were clamoring for his services.

Gore joined the Chicago White Stockings for the 1879 season, following what is considered to be the first holdout in baseball history. Chicago owner A.G. Spaulding offered him $1,200, whereas Gore said he wanted $2,500. Eventually, they compromised on $1,900, good money for a twenty-three-year-old with two seasons of professional experience.

Gore had a highly successful big-league career lasting from 1879 to 1892. He played on seven pennant-winning teams, five with Chicago and two with the New York Giants. As already noted, in his second season he led the league in hitting. Gore's ability to get walks, as well as hit for power, made him an outstanding leadoff hitter. He averaged more than one run a game for his career in an era when runs were hard to come by. In the outfield, he was an excellent center fielder who once recorded five assists in one game. His seven steals in one game in 1881 set a Major League record, as did his five extra-base hits (two doubles and three triples) in 1885, although both marks have since been tied.

Other aspects of Gore's career were less noteworthy. In the 1885 World Series, he was suspended for drunkenness and replaced in the outfield by the future evangelist and teetotaler Billy Sunday, who was also a pretty good ballplayer. A year later, Gore's drinking led team owner Spaulding to sell

George Gore in 1891, shortly before his retirement from baseball. Gore reportedly went on to become a successful businessman. *National Baseball Hall of Fame Library, Cooperstown, New York.*

him to the New York Giants. Baseball writer Henry Chadwick said, "Gore cannot play in harmony with team captain and Manager Cap Anson and Mr. Spaulding has wisely released a discontented player whose skills were offset by his unpleasant relations with the team captain." When he left the team, Gore reportedly told Anson that his team would never win another pennant under his management, and it never did.

Gore played a few more years, and in 1888 and 1889 he helped the Giants win the World Series. Age and his playboy ways began to catch up with him, however, and by 1892 his big-league career was over. In his autobiography, *A Ballplayer's Career,* Cap Anson wrote, "Gore was a good ball player but women and wine brought about his downfall." "Piano Legs" lived to the age of seventy-six, however, which would suggest that he overcame his youthful dissipations.

Baseball statistician and historian Bill James ranks Gore as the fortieth best center fielder of all time and the best player in the National League in 1880. Writer John Shiffert agrees: "There are quite a few worse players in the Hall of Fame. Though he has virtually no chance of being elected at this late date, his induction would certainly not lower the standards of the Hall."

So think back to the days when Chester Arthur sat in the White House and George Gore roamed the outfields of the National League. Perhaps there is yet a place for him in Cooperstown?

THE DIVA: LILLIAN NORDICA

Lillian Norton, known as Nordica, was described as the most glamorous American opera singer of her day when she died in 1914 at the age of fifty-

seven. That she was a native of Maine is certainly less well known. In the late nineteenth and early twentieth centuries, Madame Nordica was acclaimed as one of the leading sopranos in the world, with her powerful, clear voice and an ability to perform a wide range of roles in Italian, German and French operas.

The youngest of six girls, Lillian was born on a small farm in Farmington, Maine. At the age of eight, the family moved to Boston to continue the musical education of her older sister Wilhelmina. Unfortunately, Wilhelmina died shortly thereafter. Her parents then focused their attention on Lillian's musical education. They were not well off, and she had to take a part-time job to help with family finances. As Lillian recalled later:

> *I was the sixth girl and I think by the time I came along my parents were rather worn out. I wasn't even baptized. I studied first in Boston, but I made my concert debut in New York at the old Madison Square Garden.*

Lillian proved to be an outstanding student, and at the age of eighteen she graduated with high honors from the New England Conservatory of Music. While still at the conservatory, she made her debut as a soloist with the Handel and Haydn Society. At the age of twenty-one, she

Lillian Norton was born in 1857 in this house in Farmington, Maine. Today, the Nordica Homestead contains memorabilia dedicated to the memory of the great singer. *Courtesy of Nordica Homestead Museum, Farmington, Maine.*

Lillian Norton as a student in Paris in 1878. She changed her name to Lillian Nordica the next year when she moved to Milan. *Courtesy of Nordica Homestead Museum, Farmington, Maine.*

began her professional career, singing for $100 a week with Patrick Gilmore's Grand Boston Band. (Gilmore's band was a forerunner of the concert bands of John Philip Sousa and Arthur Pryor.) She accompanied the band on tours of the United States, France and England, including the Crystal Palace in London.

The Civil War and Beyond

In 1879, Lillian left Gilmore and moved to Italy to study under the great Italian maestro Antonio Sangiovanni at the Conservatory of Music in Milan. At the Teatro Manzoni, she made her European debut as Elvira in *Don Giovanni*. In Brescia, she performed Violetta in *La Traviata* and received nine curtain calls. Lillian was the talk of the Italian opera scene, and opera buffs came to Milan from all over Italy to hear the sensational young soprano from America. At her final performance in Milan, she received thirteen curtain calls.

One of the reasons for Lillian's popularity in Italy was that Sangiovanni persuaded her that the name Lillian Norton sounded too drab. He urged her to change it to something more exotic that European audiences could appreciate. As a result, Lillian Norton became Giglio Nordica, "Lily of the North," or Madame Nordica. Eventually, she was simply known as Nordica.

When she heard Nordica sing, Cara Louise Kellogg was a well-established prima donna in Italian opera. Kellogg, also an American, paid Lillian a great compliment in her *Memoirs*:

> *My admiration for Mme. Nordica is deep and abounding. Her breathing and tone production are about as nearly perfect as anyone's can be, and if I wanted any young student to learn by imitation, I could say to her, "Go and hear Nordica, and do as nearly like her as you can." There are not many singers, nor have there ever been many, of whom one could say that. And one of the finest things about this splendid vocalism is that she has had nearly as much to do with it as had God Almighty in the first place.*

In 1880, Nordica moved to Russia with her mother, Amanda, and her second cousin, soon to be her first husband, Frederick Gower. Lillian was hired to sing ten secondary roles at the Imperial Opera in St. Petersburg. With six weeks to go before the season started, Nordica memorized ten new roles. All the while, she was learning Russian and German. She was already proficient in French and Italian.

The *Augusta Journal*, referring to Nordica and Frederick Gower, reported:

> *Two natives of Maine are just now creating quite a sensation in Europe. Miss Norton has been engaged by the St. Petersburg Opera for $1,000 and the next season her salary will double...She has created a furor in St. Petersburg and Moscow when she dined with the Czar and the Imperial Family.*

Above, left: Nordica married Frederick Gower in 1883, the first of her three husbands. Gower died in a hot air balloon accident in 1885. *Courtesy of Nordica Homestead Museum, Farmington, Maine.*

Above, right: Nordica as Brunhilde in Wagner's Ring cycle of operas, 1898. *Courtesy of Nordica Homestead Museum, Farmington, Maine.*

A sad note is that Lillian's performance for Tsar Alexander XI came just a week before he was assassinated in 1881.

In 1883, Nordica married Gower, a successful businessman who had made a fortune setting up telephone companies with Alexander Graham Bell. Gower, however, was not an easy husband and was jealous of Lillian's career. He hated opera and urged her to stop singing. Needless to say, the marriage was not a success. Lillian was suing him for divorce in 1885 when Gower disappeared in a hot air balloon flight over the English Channel. His body was never found.

Nordica's career continued to soar through the 1880s. She was known as an "adventurous artist with a big, pure-toned soprano voice." Her varied repertoire included *Aida, Tristan and Isolde, Lohengrin, La Traviata, Il Trovatore, La Gioconda, Faust* and *Les Huguenots*. As her reputation increased, Nordica was invited by Richard Wagner's widow, Cosima, to appear at Bayreuth and sing the role of Elsa in *Lohengrin*. (She was the first American woman to be so honored, and there was great surprise that a

soprano could sing Wagnerian roles in tune.) Lillian knew the opera in Italian but not German. As Lillian said, "I lived with her [Cosima] for three months, which was a great privilege for me. She taught me German and helped me in every way."

Cosima Wagner said of Nordica, "Her voice, intelligence and capacity for expression are extraordinary. I hope for the best." To this, Wagner's son Seigfried added, "With an artist of her talent and reputation it is really touching to watch with what indefatigable zeal she dedicates herself to the perfection of her role."

Nordica's performance was a critical success. She wrote to her aunt:

> *Well, when the day arrived, the opera fitted like an old glove and I was not at all nervous, but I kept my mind on my business...I felt that the eye of the musical world was upon me and that the stars and stripes were in my keeping and must be brought forth in victory.*

It was later said that Lillian's creation of the role of Elsa in *Lohengrin* at Bayreuth was perhaps the high watermark in the three decades known as the Golden Age of Opera.

Following her mother's death in 1891, Lillian's private life had become increasingly empty. Frequently, the man singing opposite her was Zoltan Doehm, an attractive young Hungarian baritone. They became good friends and eventually got engaged, though Lillian was in no rush to get married again.

In 1896, when Nordica was performing in Indianapolis, Doehm suddenly appeared and insisted that they get married. As Kate Kennedy described in her recent book, *More than Petticoats*:

> *For all her level-headedness and discipline when it came to singing, Lillian was foolish in her romantic life. During the seven years their marriage lasted, Dome [sic] was vain and lazy and a notorious philanderer. Finally, after one too many proofs of his infidelity, she sued for divorce.*

Nordica sang with all the greats of her day. She appeared in a revival of *La Gioconda* with Enrico Caruso at the Metropolitan Opera Company in 1904. When asked if she had ever met Verdi, she replied, "I met in Italy, but only once. I was better acquainted with Gounod and the modern composers Leoncavallo and Mascagni." Frequently, her partner was Jean de Reszke, who was proving, like Lillian, that Wagner's demanding scores could be sung

as the composer desired. It was a great event when Jean de Reszke and Nordica appeared as *Tristan and Isolde*.

Toward the end of her life, Nordica used her influence as an opera diva to become active in women's rights. In the early twentieth century, this activity particularly focused on the issue of women's suffrage. In 1911, while in San Francisco for a concert, she spoke in favor of the women's suffrage amendment that was under consideration by the state legislature. Later that year, she was indignant when she heard that a Texas court had forced a woman from that state to pay her drunken husband (whom she had left) $1,500 that she had recently earned.

By 1913, Nordica was in poor health. In 1909, she had rather impulsively married for the third time. George W. Young was a prominent New York socialite and financier who had reportedly sent Lillian an emerald necklace as a present after hearing one of her concerts. They were still married at the time of her death, but the marriage had not been a happy one.

By the age of fifty-seven, the great Nordica's voice was in decline. This did not stop her from embarking on a strenuous tour that extended from the Pacific coast to Honolulu to Australia. She almost missed the ship in Sydney but wired the captain, asking him to "hold the boat" until she arrived. Off the coast, the ship hit a reef, where it was battered by a storm for three days before it could be towed off. Lillian suffered from exposure and developed pneumonia. She died three months later, on May 10, 1914, on the island of Java.

Three months after her death, World War I broke out, but Lillian Nordica has not been forgotten. The Nordica Homestead Museum in Farmington was opened in 1927 and displays many of the artifacts from her great career. In March 1943, Nordica received another honor. USS *Lillian Nordica* was launched in South Portland, the first Liberty ship to be named for a musical artist. And at the University of Maine in Farmington, Nordica Auditorium in Merrill Hall is named in her honor.

THE AUTHOR: KENNETH ROBERTS REVISITED

With Kenneth Roberts we have come full circle. This book began with stories about Maine during colonial times. It seems appropriate to conclude by remembering an author who wrote extensively about Maine before, during and after the American Revolution. In 1945, his friend Ben Williams wrote

in the introduction to *The Kenneth Roberts Reader*, "It is doubtful whether any living man knows as much about the first half century of American history." Even when taking into account the natural enthusiasm of a friend, this is still an impressive statement.

Kenneth Roberts died in 1957 at the age of seventy-one. Admittedly, he is not yet part of Maine's hidden history, although it is probably safe to say that he is not as well known as he was fifty years ago. As a boy, I read a number of Roberts's books, though I knew next to nothing about him as a person. What I did know was that he was a prolific writer of historical fiction and that I enjoyed the stories he told. Historian Henry Steele Commager went further: "Few novelists have done more to re-create the past for us, vividly and authentically."

What I have discovered since my earlier readings was that Roberts was a fiercely independent, frequently cranky New Englander. In the first chapter of his 1949 autobiography, *I Wanted to Write*, he described himself:

> *I have been accused of hermitcy or recluse-ism because I stay at home and work while others sit in the sun on the beach: because I shun cocktail parties and large gatherings of distractomaniacs. If that's being a hermit or a recluse, I plead guilty.*

His publisher, Nelson Doubleday, visited Roberts at his Kennebunkport home several times and described his approach to the house up a half-mile driveway: "There are two small direction boards reading: PRIVATE: DEAD END ROAD, NARROW AND DANGEROUS: PLEASE DON'T TRESPASS. NOT A PUBLIC ROAD." In spite of the warnings, Roberts told Doubleday that summer vacationers "persistently ignored" the signs.

Although he traveled the world, Roberts was a proud resident of Maine for most of his life. He grew up listening to his grandmother tell stories about their Arundel relatives (the name was changed to Kennebunkport in 1821) who fought in the American Revolution. When he pressed her for more information about "the little people, the men who sailed the ships and stopped the bullets," his grandmother could tell him nothing. His curiosity piqued, Roberts's life as a historian had begun.

Roberts got his start as a novelist through the support of his friend, fellow author and Kennebunkport neighbor Booth Tarkington. Tarkington, who was half a generation older, told him to stop writing magazine articles and concentrate on fiction. The older man agreed to edit Roberts's first novel and ultimately ended up editing all of his

Kenneth Roberts's home, Rocky Pasture, as seen in 1939. The house burned down in 1975. Roberts shunned public attention and was a self-admitted recluse. *Courtesy of Maine Memory Network.*

historical novels, including extensive revisions to *Oliver Wiswell* and *Northwest Passage*. Not surprisingly, both books, as well as *Rabble in Arms*, are dedicated to Mr. Tarkington.

Roberts's books have aged remarkably well. Most of his novels are about people from coastal Maine—"his other Eden," a critic called it. As he explained in his autobiography, "I wanted to give the people of Maine an honest, detailed and easily understood account of how their forebears got along." Insatiably curious about the lives of his ancestors, he used their experiences as a basis for many of his novels, starting with *Arundel*, published in 1929. In *Northwest Passage* (1936), considered by many to be his finest novel, he writes about the French and Indian War. In *Arundel*, *Oliver Wiswell* and *Rabble in Arms*, his subject is the American Revolution, and *The Lively Lady* and *Captain Caution* are about the War of 1812.

Interestingly, and in keeping with his contrary personality, Roberts often focused on controversial persons in his books. He admired Benedict Arnold, and he sympathized with the Loyalists during the American Revolution. Arnold is a key figure in both *Arundel* and *Rabble in Arms*, and *Oliver Wiswell* is about the adventures of a Tory during the Revolution.

An eccentric Yankee, Roberts's autobiography is filled with his intense opinions. He was a Republican who detested Franklin Roosevelt. It is said that visitors to his house found Roosevelt dimes glued to clamshells, which he used as ashtrays—the better to grind ashes in FDR's face! He deplored the deteriorating state of Maine's highways, "embellished with billboards, sardine tins, old shoe boxes and lunch containers." When the Maine Turnpike was built, he fought a losing battle against that "august authority." He had no use for American education:

> *A mind loaded with little scraps of information on Egyptian history, zoology, Oriental art, the poets of the Renaissance and similar intellectual detritus is not trained. It might be called a human New England attic: A repository of useless and forgotten things.*

Nor was the rest of the world spared. Visiting Oxford, he was appalled by English weather, "fit for Siberia." The ineffectiveness of the British

Three friends take a walk. Roberts, on the left, is seen here with the inventor Atwater Kent in the middle and his mentor, the writer Booth Tarkington, on the right. *Courtesy of Library of Congress, Prints and Photographs Division.*

college system bothered him. "There are many young men who leave with their brain cavities almost completely vacant." Athletics at Oxford seemed excessive: "There are more teams to the acre than there are potatoes to the acre in Aroostook County."

As for spending winters in Italy, which he did for ten years, he wrote:

> *Everyone in America knows that Italy is "Sunny Italy." As I write this I'm wearing woolen underwear, two sweaters, felt boots, a muffler and a heavy winter overcoat. When the winds blew, and they were seldom still, drifts of grit whirled about the floor and up the trouser leg. Our heating system was an inadequate fireplace that smoked villainously.*

Roberts chose to work in a remote palazzo in Italy where he would have no diversions or disturbances. "I wished a retreat so far removed from the bright lights that while I was in it, I was forced to write in order to preserve my sanity."

Roberts generated controversy all through his life. As a Cornell undergraduate, he frequently wrote articles for the college newspaper attacking the school's administration. Throughout his career as a writer, he denounced historians for what he considered to be their deliberate falsification of history. When he met Henry Gross, a retired Maine game warden and amateur water dowser, Roberts spent his final decades attacking scientists at the Department of the Interior for discrediting "water witching," as water divining was called. In *Experiments with a Forked Twig*, Roberts responded:

> *Water dowsing isn't the only manifestation that baffles scientists. They are similarly baffled by the curve ball, saying there is no such thing, whereas anyone who has played baseball knows that this coterie is stupidly, overwhelmingly and idiotically wrong.*

Roberts devoted a chapter in his autobiography to a critique of the Pulitzer Prize, first given in 1917, "to encourage American authors to write books on the American scene." Although he considered Joseph Pulitzer "an editorial genius," Roberts spent much of the chapter criticizing the administrators of the award for excessively broadening its scope. "Mr. Pulitzer's plan for improving American literature has had its throat handsomely cut." Two months before he died in 1957, in what can only be considered delightful irony, Roberts was awarded a Special Pulitzer Prize Citation "for his historical

Kenneth Roberts in a jovial moment with his dog at home in Kennebunkport, Maine. The picture was taken on July 27, 1939. *Courtesy of Maine Memory Network.*

novels which have long contributed to the creation of greater interest in our early American history."

In 1911, Roberts married Anna Mosser from Boston, and she must have been a saint. She typed and retyped his manuscripts, often in unheated apartments during the winter. Until the success of *Northwest Passage* in 1936, they had very little money. He called her "patient and long-suffering," and he completely depended on her. "Anna says we can't spend a penny until we get a check from the *Post*. All writers should learn to live on spaghetti for months on end. It's delicious."

At least Kenneth Roberts had a sense of humor. "Anna says I ought to have a theme song, so I wrote one for her":

> *I wonder what's eating him now:*
> *At what he is raging—and how!*
> *I wonder what's making him squawk and yell,*
> *Beef and howl and roar like hell.*
> *I wonder what next he'll rewrite?*
> *All day and through most of the night*
> *I wonder what tripe I will next have to type.*
> *I wonder what's eating him now!*

BIBLIOGRAPHY

Anderson, Hayden L.V. *Canals and Inland Waterways of Maine*. Maine Historical Society Research Series No. 2. Portland: Maine Historical Society, 1982.

Anderson, Will. *Was Baseball Really Invented in Maine?* Portland, ME: Will Anderson Publisher, 1992.

Barnes, Viola F. *PHIPPIUS MAXIMUS*. Boston: New England Quarterly, 1928.

Bourne, Russell. *The Penobscot Fiasco*. Rockville, MD: American Heritage Publishing Co., 1974.

Buker, George. *The Penobscot Expedition: Commodore Saltonstall and the Massachusetts Conspiracy of 1779*. Annapolis, MD: Naval Institute Press, 2002.

Caldwell, Bill. *The Islands of Maine*. Portland, ME: Guy Gannett Publishing Co., 1981.

———. *Rivers of Fortune*. Portland, ME: Guy Gannett Publishing Co., 1983.

Callahan, North. *Henry Knox: General Washington's General*. New York: Rinehart & Co., 1958.

Clark, Charles E. *Maine: A History*. Hanover, NH: University Press of New England, 1977.

Duncan, Roger F. *Coastal Maine: A Maritime History*. Woodstock, VT: The Countryman Press, 1992.

———. *History of Penobscot County, Maine*. Cleveland, OH: Williams, Chase & Co., 1882.

Eaton, Cyrus. *A History of Thomaston*. Hallowell, ME: Masters, Smith & Co. Printers, 1865.

Eskew, Garnett L. *Cradle of Ships*. New York: G.P. Putnam's Sons, 1958.

Hanson, J.W. *A History of Gardiner, Pittston and West Gardiner, 1602–1852.* Hallowell, ME: Smith & Company, 1852.

Howe, Octavius T., and Fredric C. Matthews. *American Clipper Ships 1833–1858.* Vol. I, *Adelaide-Lotus.* Salem, MA: Marine Research Society, 1926.

Kennedy, Kate. *More than Petticoats: Remarkable Maine Women.* Guilford, CT: Two Dot Press, 2005.

McCully, Emily Arnold. *Marvelous Mattie: How Margaret E. Knight Became an Inventor.* New York: Farrar, Straus and Giroux, LLC, 2006.

McKee, Christopher. *Edward Preble.* Annapolis, MD: Naval Institute Press, 1972.

Morison, Samuel Eliot. *The Story of Mount Desert Island.* Frenchboro, ME: Islandport Press, Inc., 1960.

Nelson, James L. *Benedict Arnold's Navy.* Camden, ME: McGraw Hill, 2006.

Owen, Henry Wilson. *The Edward Clarence Plummer History of Bath, Maine.* Bath, ME: Bath Area Bicentennial Committee, 1976.

Patton, Robert H. *Patriot Pirates.* New York: Pantheon Books, 2008.

Pike, Robert E. *Tall Trees, Tough Men.* New York: W.W. Norton & Company, 1967.

Pleasants, Henry. *The Great Singers.* New York: Simon and Schuster, 1966.

Price, H.H., and Gerald Talbot. *Maine's Visible Black History.* Gardiner, ME: Tilbury House, 2006.

Puls, Mark. *Henry Knox: Visionary General of the American Revolution.* New York: Palgrave Macmillan, 2008.

Rich, Louise Dickinson. *The Coast of Maine.* Camden, ME: Down East Books, 1975.

Roberts, Kenneth. *I Wanted to Write.* Garden City, NY: Doubleday & Company, 1949.

———. *The Kenneth Roberts Reader.* Garden City, NY: Doubleday & Company, 1945.

Rudy, Amanda. "Henry Knox and His Hobby Horse: The Georges River Lock and Canal System." Unpublished paper written for the General Henry Knox Museum, Thomaston, Maine, 2006.

Sanderson, Virginia Somes. *The Living Past.* Mount Desert, ME: Beech Hill Publishing Company, 1982.

Shroeder, J.F. *The Life and Times of Washington.* Albany, NY: M.M. Belcher Publishing Co., 1903.

Snow, Ralph L. *Bath Iron Works: The First Hundred Years.* Bath: Maine Maritime Museum, 1987.

Stakeman, Randolph. "Slavery in Colonial Maine." *Maine Historical Quarterly* (1987).

Stanley, Autumn. *Mothers and Daughters of Invention*. New Brunswick, NJ: Rutgers University Press, 1995.

Stover, Arthur Douglas. *Eminent Mainers*. Gardiner, ME: Tilbury House, 2006.

Street, George. *Mount Desert: A History*. Boston: Houghton Mifflin Company, 1926.

Thornton, Nellie. *Traditions and Records of Southwest Harbor and Somesville*. Bar Harbor, ME: Southwest Harbor Public Library, 1988.

Toll, Ian W. *Six Frigates*. New York: W.W. Norton & Company, 2006.

Van Horn, David. *A Brief History of Penobscot Bay*. Castine, ME: Robert's Press, 2003.

Webb, Stephen S. *Lord Churchill's Coup*. New York: Alfred A. Knopf, 1995.

ARCHIVAL MATERIALS CONSULTED AT THE FOLLOWING LOCATIONS

Arnold Expedition Historical Society, Pittston, ME
Bangor Museum and Center for History, Bangor, ME
Bangor Public Library, Bangor, ME
Bar Harbor Historical Society, Bar Harbor, ME
General Henry Knox Museum, Thomaston, ME
Maine Historical Society, Portland, ME
Maine Maritime Museum, Bath, ME
National Baseball Hall of Fame, Cooperstown, NY
North Haven Historical Society, North Haven, ME
Patton Free Library, Bath, ME
Penobscot Marine Museum, Searsport, ME
Portland Public Library, Portland, ME
Rockland Historical Society, Rockland, ME
Rockland Public Library, Rockland, ME
Vinalhaven Historical Society, Vinalhaven, ME
Vinalhaven Public Library, Vinalhaven, ME
Warren Historical Society, Warren, ME

ABOUT THE AUTHOR

Photo by Thomas Levy.

Harry Gratwick is a lifelong summer resident of Vinalhaven Island in Penobscot Bay. Recently retired, Gratwick enjoyed a forty-six-year career as a secondary school history teacher, coach and administrator. He spent most of these years at Germantown Friends School in Philadelphia, Pennsylvania, where he chaired the History Department and coached the varsity baseball team.

This book combines two of Harry's passions: his love of history and of the sea. He has cruised the Maine coast from Casco Bay to Mount Desert. He is an active member of the Vinalhaven Historical Society and has written extensively on maritime history for two Island Institute publications, the *Working Waterfront* and the *Island Journal*.

Gratwick is a graduate of Williams College and has a master's degree from Columbia University. Harry and his wife, Tita, spend the winter months in Philadelphia. They have two grown sons, a Russian daughter-in-law and two grandsons. *Hidden History of Maine* is his second book.

Visit us at
www.historypress.net